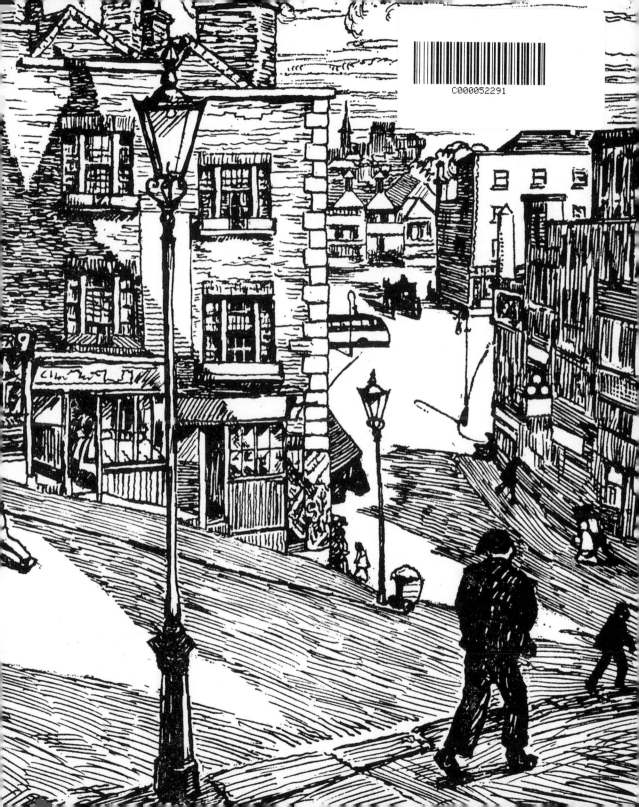

National Gallery *of* Ireland
Gailearaí Náisiúnta *na* hÉireann

DIARY 2013

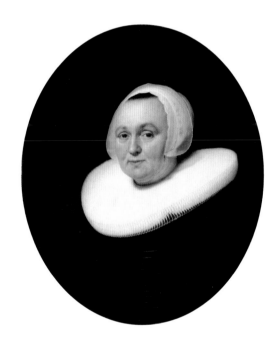

National
Gallery *of*
IRELAND

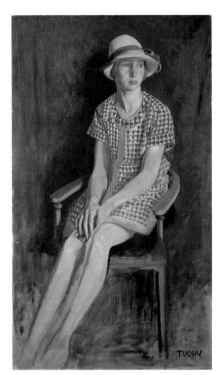

Patrick Joseph Tuohy, *Portrait of the Honourable Biddy Campbell, Daughter of the 2nd Lord Glenavy,* **1926**

The sitter in this portrait, wearing a straw hat and a red and blue check dress, is Biddy, the daughter of Beatrice *(née* Elvery) and Gordon Campbell, Lord and Lady Glenavy. Tuohy requested so many sittings from Biddy, who was then 12 or 13 years old, that she eventually refused to pose. This may account for her rather despondent expression, but her parents were pleased with the portrait. Biddy and her husband died in a bombing raid on London during the Second World War.

FRONT COVER Francisco José de Goya y Lucientes, *Doña Antonia Zárate,* **c.1805–06**

This lady was a celebrated actress and one of several stage personalities painted by Goya. An enthusiast of the theatre, he counted playwrights, actors and actresses among his friends. He accentuates her dark beauty by setting off her black gown and lace *mantilla* against the yellow damask settee. In her hands she holds a *fleco* (fan), and her arms are covered with white fingerless gloves. Her expression is direct, if slightly melancholic.

ENDPAPERS Harry Kernoff, *Untitled,* **20th century**

From an Album of Kernoff prints – 72 woodcuts, calendar illustrations, portraits, views and genre scenes.

Gill & Macmillan
Hume Avenue, Park West, Dublin 12
with associated companies throughout the world
www.gillmacmillan.ie

© The National Gallery of Ireland 2013
ISBN 9780717153732

Text researched and written by Sara Donaldson
Design by Tony Potter
Photography by Roy Hewson and Chris O'Toole / NGI
Print origination by Teapot Press Ltd
Printed in PRC

This book is typeset in Dax

The paper used in this book comes from the wood pulp of managed forests. For every tree felled, at least one tree is planted, thereby renewing natural resources.

A CIP catalogue record for this book is available from the British Library.

5 4 3 2 1

2013

January • Eanáir
M	T	W	T	F	S	S
31	1	2	3	4	5	6
7	8	9	10	11	12	13
14	15	16	17	18	19	20
21	22	23	24	25	26	27
28	29	30	31	1	2	3

February • Feabhra
M	T	W	T	F	S	S
28	29	30	31	1	2	3
4	5	6	7	8	9	10
11	12	13	14	15	16	17
18	19	20	21	22	23	24
25	26	27	28	1	2	3

March • Márta
M	T	W	T	F	S	S
25	26	27	28	1	2	3
4	5	6	7	8	9	10
11	12	13	14	15	16	17
18	19	20	21	22	23	24
25	26	27	28	29	30	31

April • Aibreán
M	T	W	T	F	S	S
1	2	3	4	5	6	7
8	9	10	11	12	13	14
15	16	17	18	19	20	21
22	23	24	25	26	27	28
29	30	1	2	3	4	5

May • Bealtaine
M	T	W	T	F	S	S
29	30	1	2	3	4	5
6	7	8	9	10	11	12
13	14	15	16	17	18	19
20	21	22	23	24	25	26
27	28	29	30	31	1	2

June • Meitheamh
M	T	W	T	F	S	S
27	28	29	30	31	1	2
3	4	5	6	7	8	9
10	11	12	13	14	15	16
17	18	19	20	21	22	23
24	25	26	27	28	29	30

July • Iúil
M	T	W	T	F	S	S
1	2	3	4	5	6	7
8	9	10	11	12	13	14
15	16	17	18	19	20	21
22	23	24	25	26	27	28
29	30	31	1	2	3	4

August • Lúnasa
M	T	W	T	F	S	S
29	30	31	1	2	3	4
5	6	7	8	9	10	11
12	13	14	15	16	17	18
19	20	21	22	23	24	25
26	27	28	29	30	31	1

September • Meán Fómhair
M	T	W	T	F	S	S
26	27	28	29	30	31	1
2	3	4	5	6	7	8
9	10	11	12	13	14	15
16	17	18	19	20	21	22
23	24	25	26	27	28	29
30	1	2	3	4	5	6

October • Deireadh Fómhair
M	T	W	T	F	S	S
30	1	2	3	4	5	6
7	8	9	10	11	12	13
14	15	16	17	18	19	20
21	22	23	24	25	26	27
28	29	30	31	1	2	3

November • Samhain
M	T	W	T	F	S	S
28	29	30	31	1	2	3
4	5	6	7	8	9	10
11	12	13	14	15	16	17
18	19	20	21	22	23	24
25	26	27	28	29	30	1

December • Nollaig
M	T	W	T	F	S	S
25	26	27	28	29	30	1
2	3	4	5	6	7	8
9	10	11	12	13	14	15
16	17	18	19	20	21	22
23	24	25	26	27	28	29
30	31	1	2	3	4	5

2014

January • Eanáir
M	T	W	T	F	S	S
30	31	1	2	3	4	5
6	7	8	9	10	11	12
13	14	15	16	17	18	19
20	21	22	23	24	25	26
27	28	29	30	31	1	2

February • Feabhra
M	T	W	T	F	S	S
27	28	29	30	31	1	2
3	4	5	6	7	8	9
10	11	12	13	14	15	16
17	18	19	20	21	22	23
24	25	26	27	28	1	2

March • Márta
M	T	W	T	F	S	S
24	25	26	27	28	1	2
3	4	5	6	7	8	9
10	11	12	13	14	15	16
17	18	19	20	21	22	23
24	25	26	27	28	29	30
31	1	2	3	4	5	6

April • Aibreán
M	T	W	T	F	S	S
31	1	2	3	4	5	6
7	8	9	10	11	12	13
14	15	16	17	18	19	20
21	22	23	24	25	26	27
28	29	30	1	2	3	4

May • Bealtaine
M	T	W	T	F	S	S
28	29	30	1	2	3	4
5	6	7	8	9	10	11
12	13	14	15	16	17	18
19	20	21	22	23	24	25
26	27	28	29	30	31	1

June • Meitheamh
M	T	W	T	F	S	S
26	27	28	29	30	31	1
2	3	4	5	6	7	8
9	10	11	12	13	14	15
16	17	18	19	20	21	22
23	24	25	26	27	28	29
30	1	2	3	4	5	6

July • Iúil
M	T	W	T	F	S	S
30	1	2	3	4	5	6
7	8	9	10	11	12	13
14	15	16	17	18	19	20
21	22	23	24	25	26	27
28	29	30	31	1	2	3

August • Lúnasa
M	T	W	T	F	S	S
28	29	30	31	1	2	3
4	5	6	7	8	9	10
11	12	13	14	15	16	17
18	19	20	21	22	23	24
25	26	27	28	29	30	31

September • Meán Fómhair
M	T	W	T	F	S	S
1	2	3	4	5	6	7
8	9	10	11	12	13	14
15	16	17	18	19	20	21
22	23	24	25	26	27	28
29	30	1	2	3	4	5

October • Deireadh Fómhair
M	T	W	T	F	S	S
29	30	1	2	3	4	5
6	7	8	9	10	11	12
13	14	15	16	17	18	19
20	21	22	23	24	25	26
27	28	29	30	31	1	2

November • Samhain
M	T	W	T	F	S	S
27	28	29	30	31	1	2
3	4	5	6	7	8	9
10	11	12	13	14	15	16
17	18	19	20	21	22	23
24	25	26	27	28	29	30

December • Nollaig
M	T	W	T	F	S	S
1	2	3	4	5	6	7
8	9	10	11	12	13	14
15	16	17	18	19	20	21
22	23	24	25	26	27	28
29	30	31	1	2	3	4

The 2013 National Gallery of Ireland Diary features a broad selection of over fifty oil paintings, drawings, watercolours, prints and stained glass, which record landscapes, seascapes, portraits, still life, genre, literary, religious and historical subjects. It highlights works from the collection by some of the world's most important Old Masters, such as Murillo, Rubens, Hals and Goya, and by the extremely important nineteenth- and twentieth-century artists Degas, Pissarro, Van Gogh and Picasso.

The National Gallery of Ireland's Irish Collection, the most important and extensive in the world, is illustrated here with works by some of this country's most talented artists, including Frederic William Burton, Walter Osborne, Roderic O'Conor, Paul Henry, Harry Clarke, William Orpen and Mary Swanzy. In addition to featuring works which are well known to visitors to the National Gallery, the 2013 Diary features several lesser-known paintings, prints, drawings, watercolours and stained glass. Some of these works are recent acquisitions, while some may not be on permanent display. For regular updates on displays and exhibitions, see *www.nationalgallery.ie, Twitter@NGIreland* and *Facebook.com/ nationalgalleryofireland.*

Founded in 1854, the National Gallery of Ireland opened to the public ten years later. The historic parts of the Gallery building, the Dargan and Milltown Wings, are now undergoing a major refurbishment project, which commenced in 2011. Throughout the term of the project the Gallery will remain open and visitors will continue to have access to the collection and research services. When completed, the refurbishment project will deliver a revitalised institution, which will provide a safe and secure home for the collection and a cultural facility that will enrich the lives of all who visit.

Moyra Barry, *Self-Portrait in the Artist's Studio,* **1920**

Moyra Barry produced still lifes, landscapes, genre scenes and portraits, but specialised in flower painting. In this spirited self-portrait, she adopts a serene, if somewhat quizzical expression as she looks up from her palette. She sports a short hairstyle and wears a black scarf, tied in a flat bow, high on her head – a manner that was highly fashionable in 1920. Her delicate facial features are carefully recorded, while her smock, palette and the studio in the background are realised with more expressive and vigorous brushwork, which shows the influence of Impressionism.

31 Monday · Luan
New Year's Eve

1 Tuesday · Máirt
New Year's Day

2013
January · Eanáir

2 Wednesday · Céadaoin

3 Thursday · Déardaoin

4 Friday · Aoine

5 Saturday · Satharn

6 Sunday · Domhnach

Antoniazzo Romano, *The Virgin invoking God to heal the Hand of Pope Leo I,* **c.1475**

The Virgin is shown imploring God to concede a miracle that is recorded in the hagiographic Golden Legend. Pope Leo I was aroused by a woman who kissed his hand during a mass and was so ashamed of his sin that he cut off his hand. The Virgin mercifully restored it in the Basilica of Santa Maria Maggiore in Rome, on the very spot where the Pope used to venerate an icon of the Virgin Advocate.

M	T	W	T	F	S	S
31	1	2	3	4	5	6
7	8	9	10	11	12	13
14	15	16	17	18	19	20
21	22	23	24	25	26	27
28	29	30	31	1	2	3

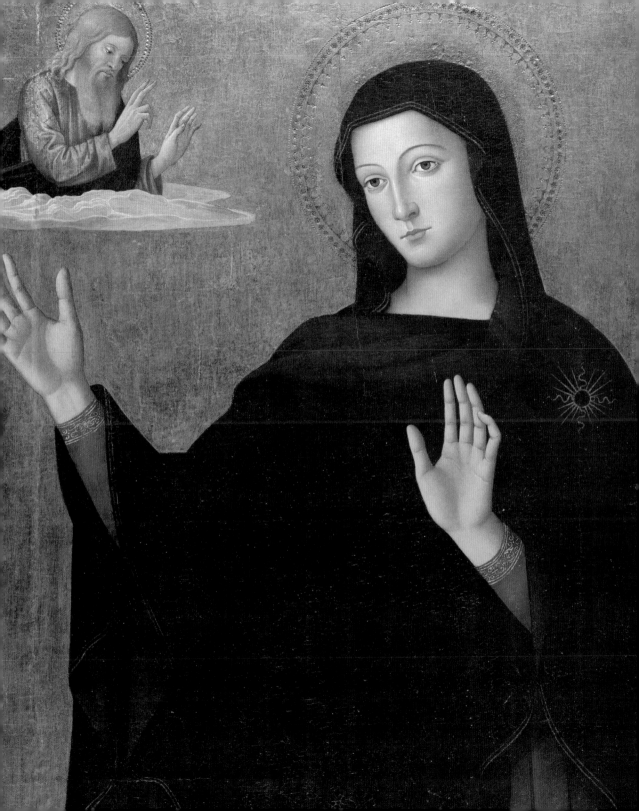

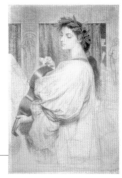

7 Monday · Luan

8 Tuesday · Máirt

9 Wednesday · Céadaoin

10 Thursday · Déardaoin

11 Friday · Aoine

12 Saturday · Satharn

13 Sunday · Domhnach

Frederic William Burton, *Cassandra Fedele, Poet and Musician,* **1869**

Cassandra Fedele, the sixteenth-century Venetian poet and musician, gently fingers her viol before a music stand. Her importance as muse of Venice is indicated by her laurel wreath, and her beauty and grace are drawn by Burton with skilful delicacy. He created this drawing when he was strongly influenced by the Pre-Raphaelite painters. Cassandra's costume is loosely inspired by Renaissance dress. Behind her, curtained bookshelves are flanked by the figures of Saints George and Sebastian.

M	T	W	T	F	S	S
31	1	2	3	4	5	6
7	8	9	10	11	12	13
14	15	16	17	18	19	20
21	22	23	24	25	26	27
28	29	30	31	1	2	3

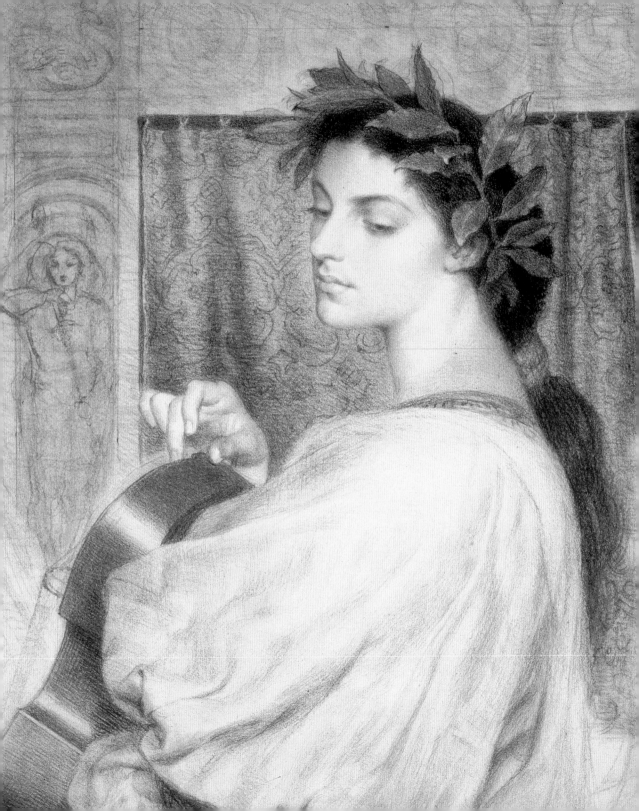

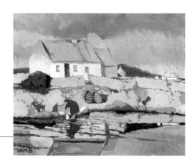

14 Monday · Luan

15 Tuesday · Máirt

16 Wednesday · Céadaoin

17 Thursday · Déardaoin

18 Friday · Aoine

19 Saturday · Satharn

20 Sunday · Domhnach

Charles Lamb, *Loch an Mhuilinn,* **1930s**

Loch an Mhuilinn (The Mill Lake) is one of several lakes in Carraroe, a peninsula off the coast of Connemara, where Lamb settled and spent much of his life painting. He often fished on the lake and this view was painted from his boat. A brightly clad local woman washes laundry in the water in front of her whitewashed cottage. Lamb employs bold colours for the cottages, mountains and boats and the woman's traditional costume.

M	T	W	T	F	S	S
31	1	2	3	4	5	6
7	8	9	10	11	12	13
14	15	16	17	18	19	20
21	22	23	24	25	26	27
28	29	30	31	1	2	3

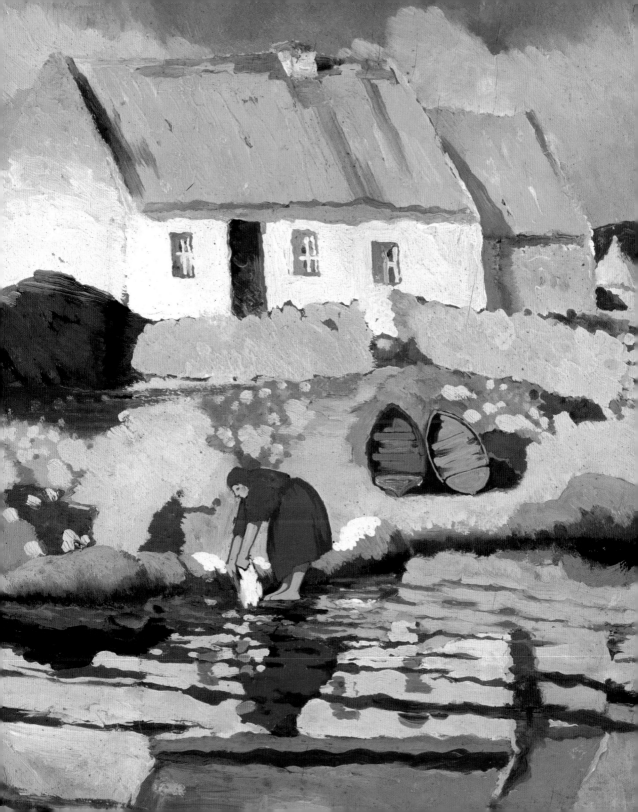

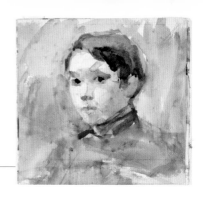

21 Monday · Luan

22 Tuesday · Máirt

23 Wednesday · Céadaoin

24 Thursday · Déardaoin

25 Friday · Aoine

26 Saturday · Satharn

27 Sunday · Domhnach

Clare Marsh, *Head of a Young Boy perhaps in Uniform,* **early 20th century**

Clare Marsh studied at the Metropolitan School of Art in Dublin and with Miss Manning, at whose studio she met fellow artist Mary Swanzy. They became friends and shared a studio from 1920. This is one of several rapidly executed watercolour sketches left in their studio when Marsh died prematurely in 1923. Her style is a blend of academic and modernist influences and her portraits of children and dogs were in particular demand during her career.

M	T	W	T	F	S	S
31	1	2	3	4	5	6
7	8	9	10	11	12	13
14	15	16	17	18	19	20
21	22	23	24	25	26	27
28	29	30	31	1	2	3

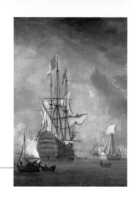

28 Monday · Luan

29 Tuesday · Máirt

30 Wednesday · Céadaoin

31 Thursday · Déardaoin

1 Friday · Aoine February · Feabhra

2 Saturday · Satharn

3 Sunday · Domhnach

Studio of Willem van de Velde the Younger, *Calm: the English Ship* Britannia *at Anchor,*
1700–10

The *Britannia*, an English ship of 100 guns, is flanked by a fishing boat and a royal yacht. In the
background a two-decker fires a gun to port. Van de Velde the Younger painted the *Britannia* in a
composition similar to this work, which may be by a studio assistant. Van de Velde the Younger and his
father moved from Holland to England and were both taken into the service of Charles II. Their assistants
produced variations of the Younger's paintings.

M	T	W	T	F	S	S
31	1	2	3	4	5	6
7	8	9	10	11	12	13
14	15	16	17	18	19	20
21	22	23	24	25	26	27
28	29	30	31	1	2	3

4 Monday · Luan

5 Tuesday · Máirt

6 Wednesday · Céadaoin

7 Thursday · Déardaoin

8 Friday · Aoine

9 Saturday · Satharn

10 Sunday · Domhnach

Augustus John, *James Joyce in October 1930,* **1930**

Augustus John visited Joyce in Paris in order to make some portrait drawings of him, one of which would adorn the frontispiece of **The Joyce Book** (1933). This was a collection of 13 of Joyce's poems, each set to music by a different composer. Joyce disliked how John portrayed his chin, an aspect about which he was sensitive. In addition, due to his failing eyesight, Joyce found it difficult to appreciate John's linear style.

M	T	W	T	F	S	S
28	29	30	31	1	2	3
4	5	6	7	8	9	10
11	12	13	14	15	16	17
18	19	20	21	22	23	24
25	26	27	28	1	2	3

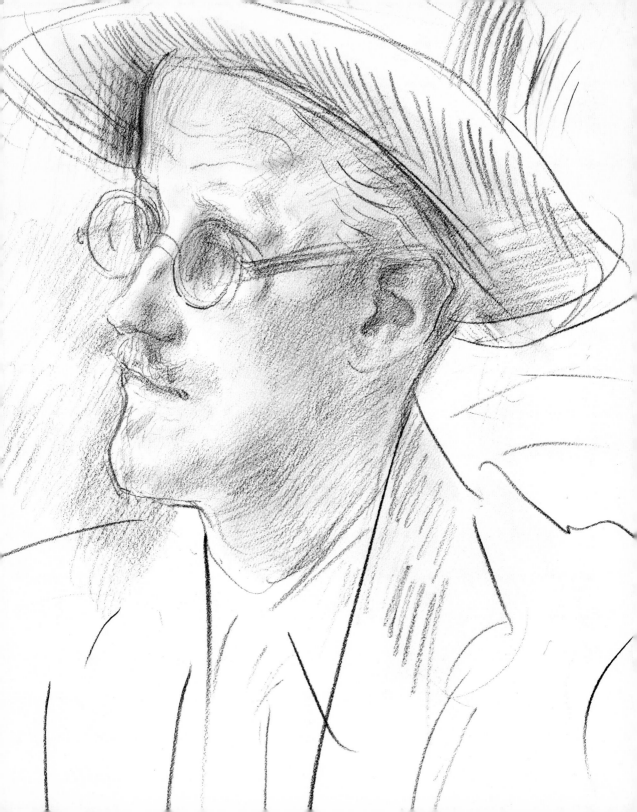

11 Monday · Luan

12 Tuesday · Máirt

13 Wednesday · Céadaoin

14 Thursday · Déardaoin
St Valentine's Day

15 Friday · Aoine

16 Saturday · Satharn

17 Sunday · Domhnach

Thomas Sword Good, *An Old Scots Woman,* **19th century**
Thomas Sword Good was born and died in Berwick, Northumberland, close to the border with Scotland. This
Scottish woman rests her hands on a stick and sets her gaze firmly on the viewer. She wears a fine black
silk cloak, the hood of which is trimmed with lace, and a Scottish linen cap or 'mutch'. She is depicted as if
outdoors with a landscape behind her and daylight falling on her aged features.

M	T	W	T	F	S	S
28	29	30	31	1	2	3
4	5	6	7	8	9	10
11	12	13	14	15	16	17
18	19	20	21	22	23	24
25	26	27	28	1	2	3

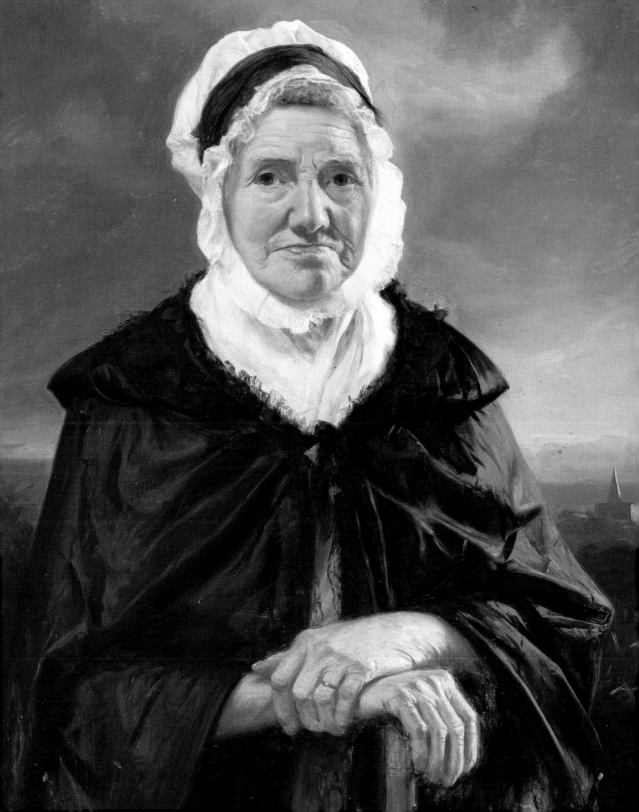

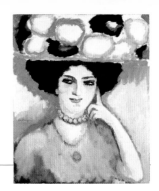

18 Monday · Luan

19 Tuesday · Máirt

20 Wednesday · Céadaoin

21 Thursday · Déardaoin

22 Friday · Aoine

23 Saturday · Satharn Gaiety Theatre 7·30 ×3

24 Sunday · Domhnach

Kees van Dongen, *Stella in a Flowered Hat,* **c.1907**

Van Dongen regularly painted the performers of the Parisian nightlife, portraying their sensuality with honesty. He became associated with Henri Matisse and the 'Fauves', a term meaning 'savages' or 'wild beasts' in reference to their use of intense colour. The violent hues employed here are decorative rather than descriptive: green for the shadows on Stella's throat and around her necklace, blue for her hair, purple around her eyes, and red outlining her arm and face.

M	T	W	T	F	S	S
28	29	30	31	1	2	3
4	5	6	7	8	9	10
11	12	13	14	15	16	17
18	19	20	21	22	23	24
25	26	27	28	1	2	3

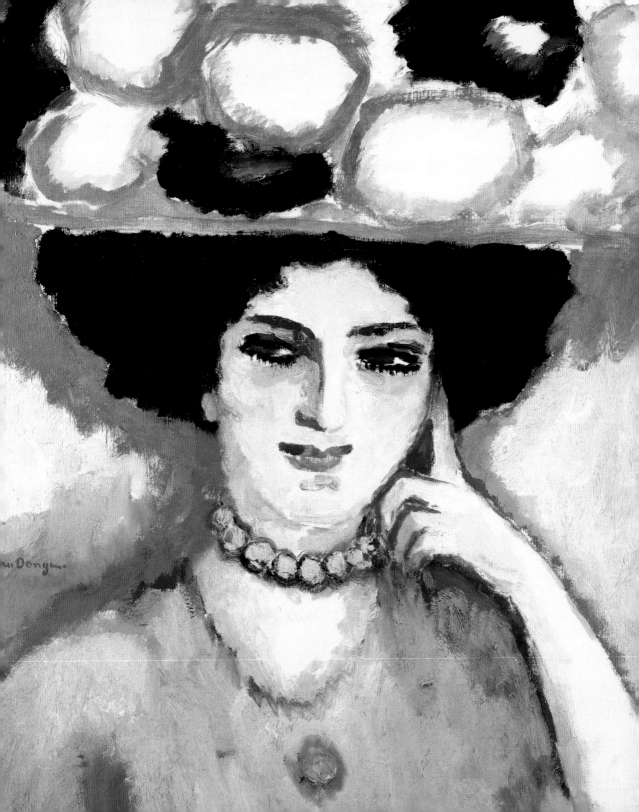

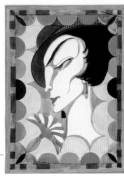

25 Monday · Luan

26 Tuesday · Máirt

27 Wednesday · Céadaoin

28 Thursday · Déardaoin

1 Friday · Aoine *8.00 pm· Olympia v3* March · Márta

2 Saturday · Satharn

3 Sunday · Domhnach

Harry Kernoff, *A Woman Holding a Flower,* **1927**

Kernoff was a painter, draughtsman and printmaker best known for his honest portrayals of the prominent figures and ordinary citizens of Dublin. He depicted Dublin's architectural and cultural heritage, was involved in the literary, artistic and theatrical scenes of the city, and worked as a book illustrator, as well as a set and costume designer. In its elegant stylisation of line and vivid, exotic colour, this striking watercolour reveals an awareness of Art Nouveau and of contemporary fashion illustration.

M	T	W	T	F	S	S
28	29	30	31	1	2	3
4	5	6	7	8	9	10
11	12	13	14	15	16	17
18	19	20	21	22	23	24
25	26	27	28	1	2	3

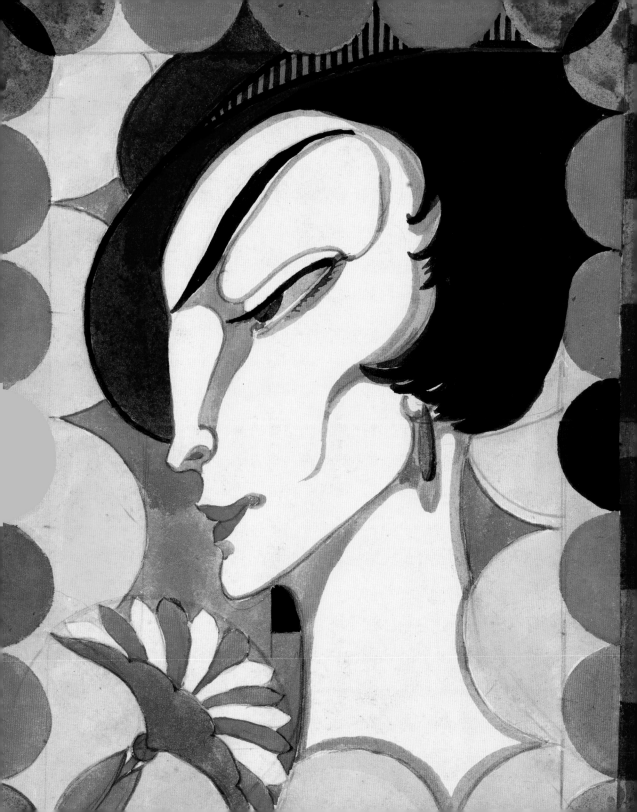

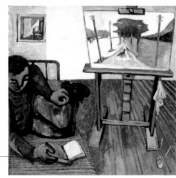

4 Monday · Luan

5 Tuesday · Máirt

6 Wednesday · Céadaoin

7 Thursday · Déardaoin

8 Friday · Aoine

9 Saturday · Satharn

10 Sunday · Domhnach

Gerard Dillon, *The Artist's Studio, Abbey Road*, **c.1940s**

For 20 years from 1945, Dillon lived and worked in the basement flat of his sister's house at 102 Abbey Road, London. A painting of a room hangs on the wall behind him, while on an easel is a snow-covered landscape with an animal resembling a fox. Dillon depicts himself reading a book on his bed, cigarette in hand. He is viewed from above, thus flattening the perspective of the room.

M	T	W	T	F	S	S
25	26	27	28	1	2	3
4	5	6	7	8	9	10
11	12	13	14	15	16	17
18	19	20	21	22	23	24
25	26	27	28	29	30	31

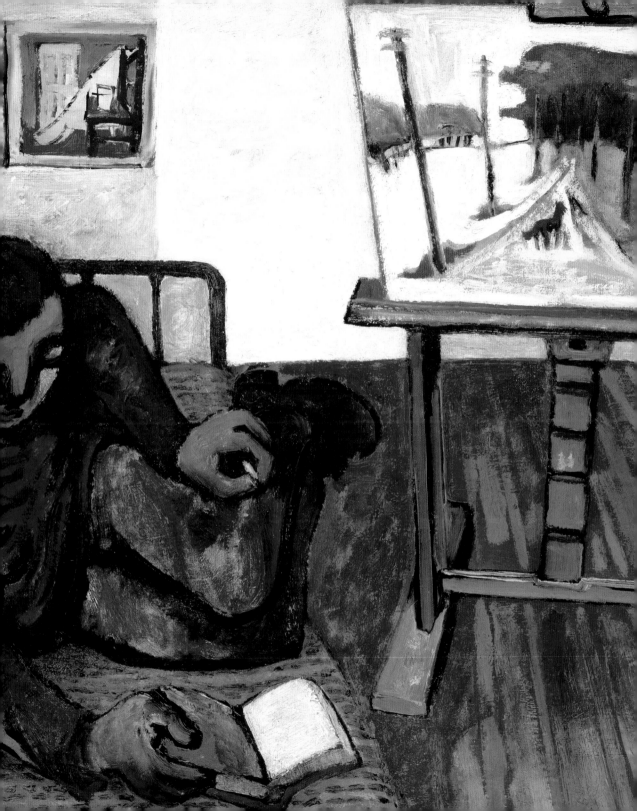

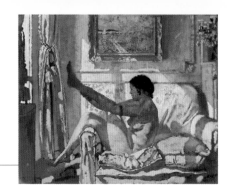

11 Monday · Luan

12 Tuesday · Máirt

13 Wednesday · Céadaoin

14 Thursday · Déardaoin

15 Friday · Aoine

16 Saturday · Satharn

17 Sunday · Domhnach
St Patrick's Day

William Orpen, *Sunlight,* **c.1925**
Although depicting a nude, the real subject of this painting, as implied by the title, is the effect of strong sunlight flooding through the window and striking the woman's body in streaks and splashes. The contrasting yellows and purples can be interpreted as Orpen's response to Post-Impressionism. Hanging on the wall is a landscape of Argenteuil by Claude Monet which Orpen owned, an indication of his vast wealth at this late stage of his career.

M	T	W	T	F	S	S
25	26	27	28	1	2	3
4	5	6	7	8	9	10
11	12	13	14	15	16	17
18	19	20	21	22	23	24
25	26	27	28	29	30	31

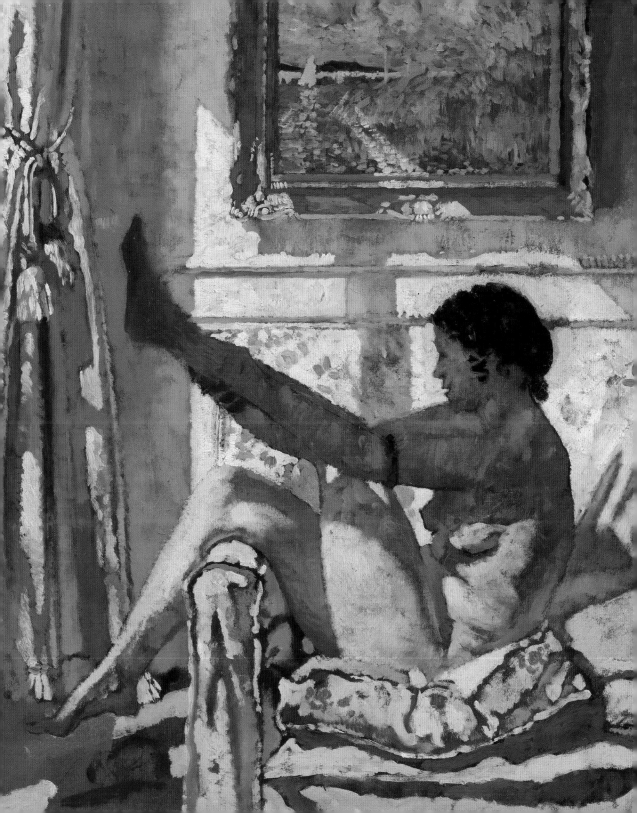

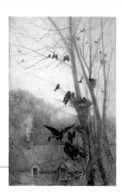

18 Monday · Luan

19 Tuesday · Máirt

20 Wednesday · Céadaoin

21 Thursday · Déardaoin

22 Friday · Aoine

23 Saturday · Satharn

24 Sunday · Domhnach

Mildred Anne Butler, *Shades of Evening,* **1904**

While studying in Cornwall in the 1890s, Butler was introduced to animal painting, which became her forte. The garden of her home at Kilmurry, County Kilkenny, was noted for its profusion of birdlife, particularly crows, jackdaws and pigeons. Butler's best-known bird subjects are groups, or clamours, of rooks, which congregated in the trees around her house, as seen here. This evocative picture captures the tranquillity of evening as the birds return to their nests before nightfall.

M	T	W	T	F	S	S
25	26	27	28	1	2	3
4	5	6	7	8	9	10
11	12	13	14	15	16	17
18	19	20	21	22	23	24
25	26	27	28	29	30	31

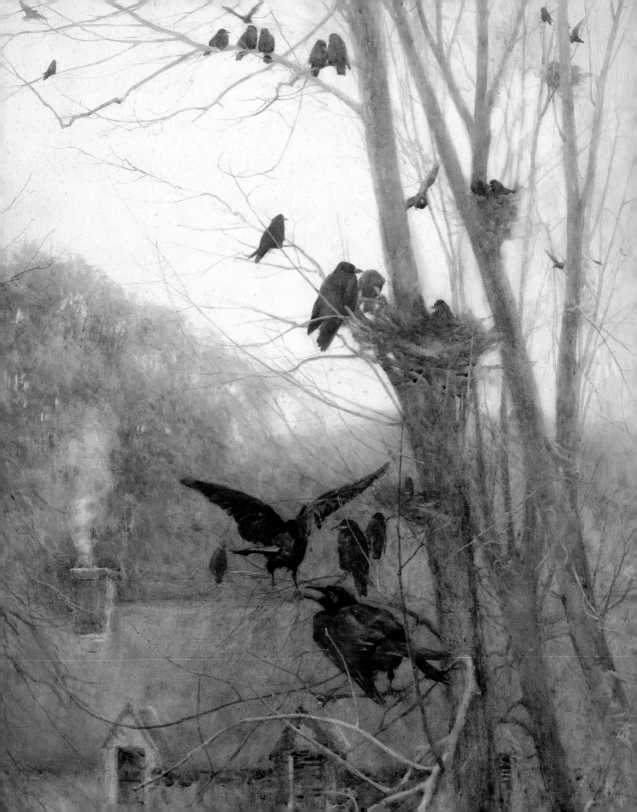

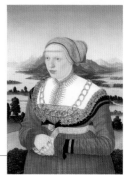

25 Monday · Luan

26 Tuesday · Máirt

27 Wednesday · Céadaoin

28 Thursday · Déardaoin

29 Friday · Aoine
Good Friday

30 Saturday · Satharn

31 Sunday · Domhnach
Easter

Conrad Faber von Creuznach, *Portrait of Katherina Knoblauch,* **1532**

Katherina Knoblauch was a member of the House of Limpurg of Frankfurt, and she was 19 years old when her portrait was painted. Her aristocratic status is indicated by the fine fabrics of her brightly coloured costume. The artist's extensive use of tooled gold leaf is evident in her headdress, her embroidered and heavily jewelled dress, the elaborate gilt belt around her waist and the rings on her fingers.

M	T	W	T	F	S	S
25	26	27	28	1	2	3
4	5	6	7	8	9	10
11	12	13	14	15	16	17
18	19	20	21	22	23	24
25	26	27	28	29	30	31

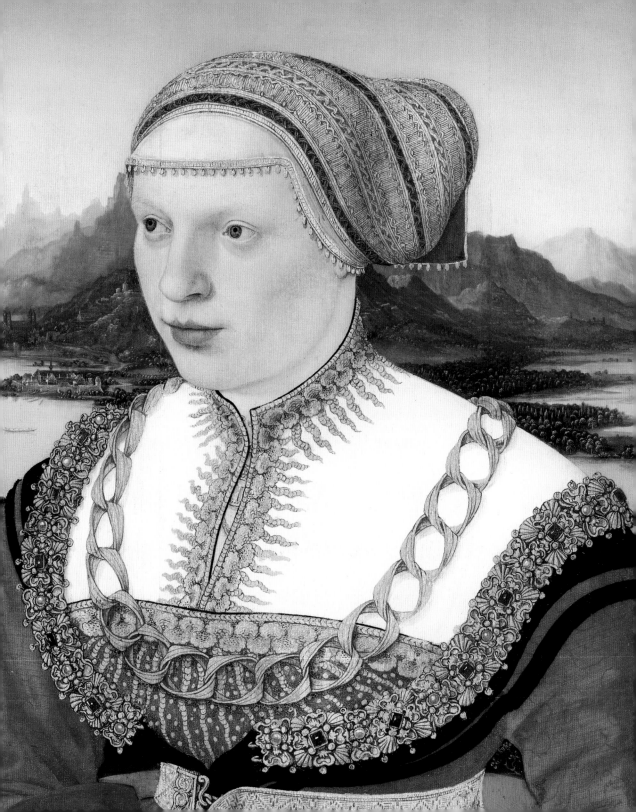

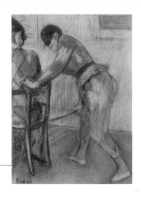

1 Monday · Luan
Bank Holiday (RoI and NI)

2 Tuesday · Máirt

3 Wednesday · Céadaoin

4 Thursday · Déardaoin

5 Friday · Aoine

6 Saturday · Satharn

7 Sunday · Domhnach

Edgar Degas, *Two Harlequins,* **c.1885**

Degas' preoccupation with the ballet and theatre led him to paint harlequins, who played the principal roles
in a type of musical theatre known as 'commedia dell'arte'. This pastel was inspired by a gala performance
at the Paris Opera on 26 February 1886. Degas was much more interested in the performers' lives
backstage or in rehearsal than in the glamour of their performances and he often captured them, as here,
in awkward poses, stretching or practising.

M	T	W	T	F	S	S
1	2	3	4	5	6	7
8	9	10	11	12	13	14
15	16	17	18	19	20	21
22	23	24	25	26	27	28
29	30	1	2	3	4	5

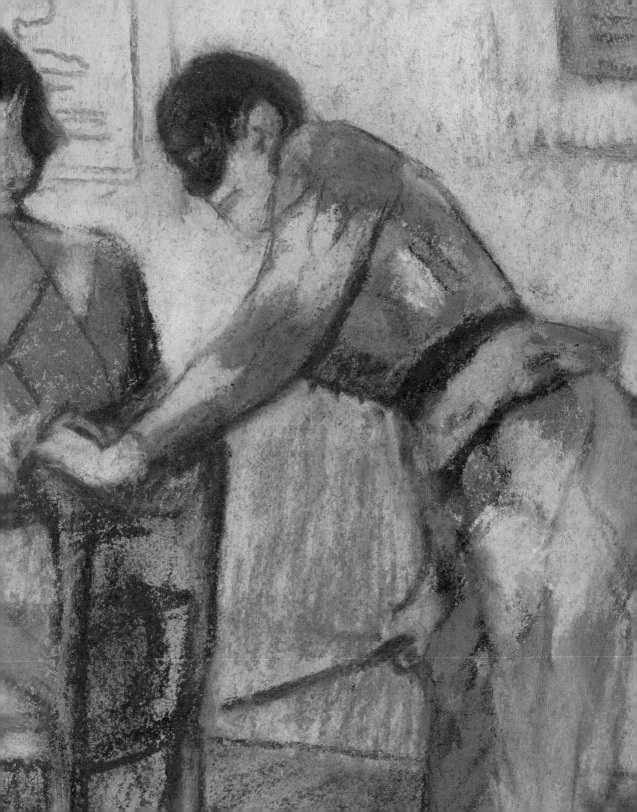

8 Monday · Luan

9 Tuesday · Máirt

10 Wednesday · Céadaoin

11 Thursday · Déardaoin

12 Friday · Aoine

13 Saturday · Satharn

14 Sunday · Domhnach

Berthe Morisot, *Le Corsage Noir,* **1878**

The black dress to which the title of this painting refers belonged to the artist. Here, a professional model poses in the gown as if dressed for an evening out. Her ensemble is completed by a neck choker, earrings, gloves and a stole over her right arm. Morisot adopts confident, broad brushstrokes for the dress, the stole and the leaves in the background, but treats the model's face and hair more delicately.

M	T	W	T	F	S	S
1	2	3	4	5	6	7
8	9	10	11	12	13	14
15	16	17	18	19	20	21
22	23	24	25	26	27	28
29	30	1	2	3	4	5

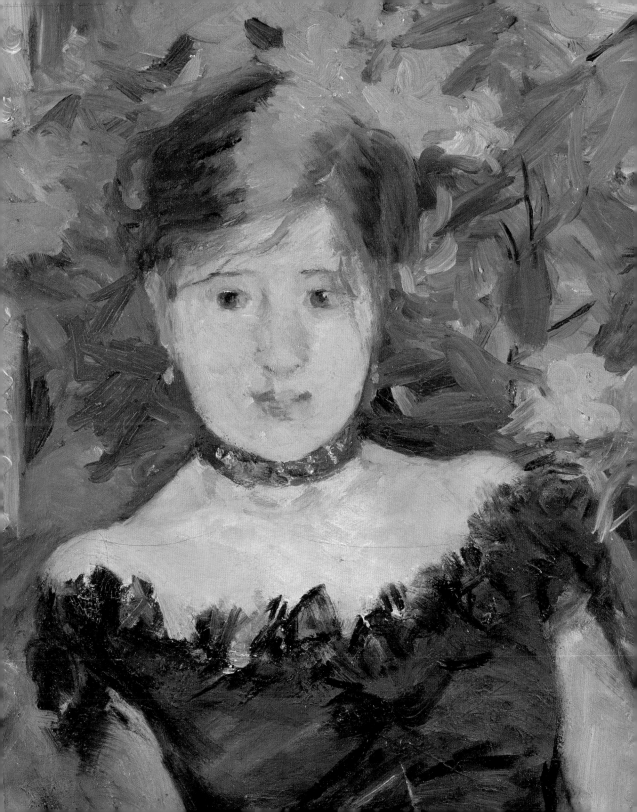

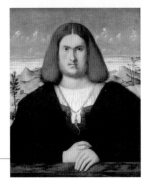

15 Monday · Luan

16 Tuesday · Máirt

17 Wednesday · Céadaoin

18 Thursday · Déardaoin

19 Friday · Aoine

20 Saturday · Satharn

21 Sunday · Domhnach

Alessandro Oliverio, *Portrait of a Young Man,* **c.1510–20**

This man is dressed in a fur cloak, an embellished doublet and a plain white chemise. Hanging from his neck is a decorated toothpick. He wears his hair in the fashionable 'zazzera' style of the 16th century, grown to the shoulders with a centre parting. This is one of several portraits by Oliverio, who worked in Venice. Inscribed on the parapet after his name in this picture is the letter V, standing for Venice or Venetian.

M	T	W	T	F	S	S
1	2	3	4	5	6	7
8	9	10	11	12	13	14
15	16	17	18	19	20	21
22	23	24	25	26	27	28
29	30	1	2	3	4	5

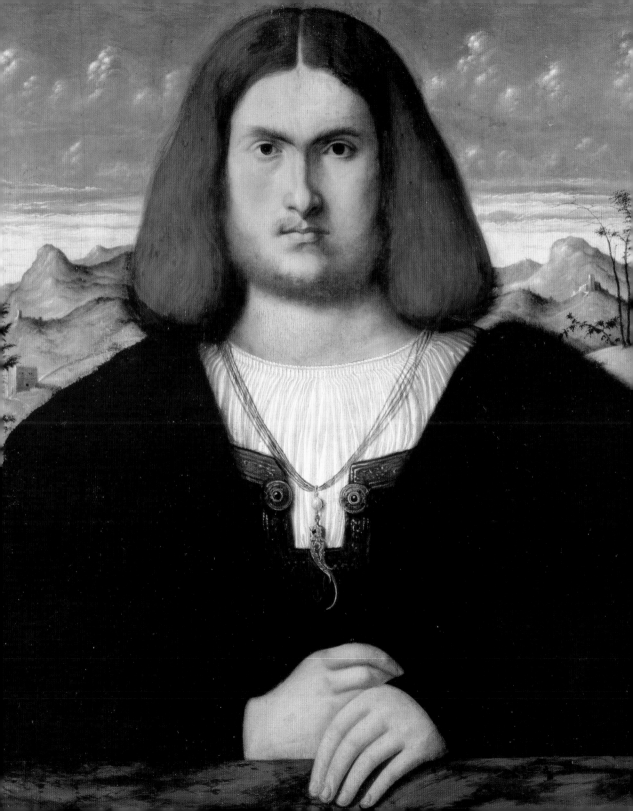

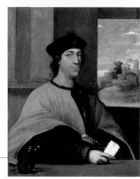

April · Aibreán
Week 17 · Seachtain 17

22 Monday · Luan

23 Tuesday · Máirt

24 Wednesday · Céadaoin

25 Thursday · Déardaoin

26 Friday · Aoine

27 Saturday · Satharn

28 Sunday · Domhnach

Sebastiano del Piombo, *Portrait of Cardinal Antonio Ciocchi del Monte,* **c.1512–15**

In this portrait Cardinal del Monte wears a 'mozzetta', the red cape signifying ecclesiastical position. His small pet monkey sits on the table beside him, and in his right hand del Monte holds a letter or official document. The composition is typical of the early portraits of Sebastiano and was painted soon after the artist's move from Venice to Rome. The picturesque landscape in the background is characteristic of Venetian taste.

M	T	W	T	F	S	S
1	2	3	4	5	6	7
8	9	10	11	12	13	14
15	16	17	18	19	20	21
22	23	24	25	26	27	28
29	30	1	2	3	4	5

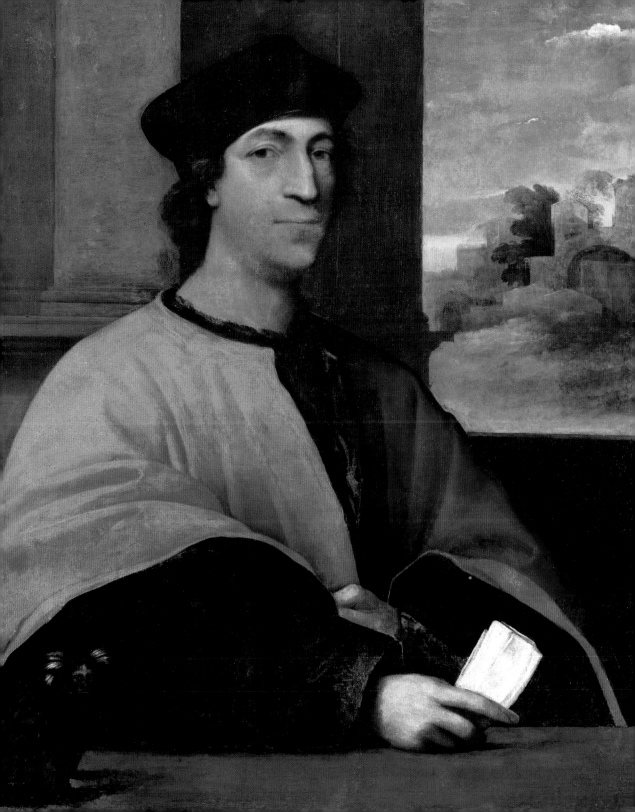

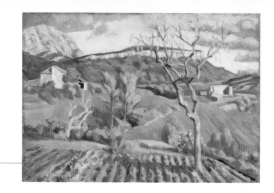

29 Monday · Luan

30 Tuesday · Máirt

1 Wednesday · Céadaoin May · Bealtaine

2 Thursday · Déardaoin

3 Friday · Aoine

4 Saturday · Satharn

5 Sunday · Domhnach

Roger Fry, *Red Earth,* **1908**
The square brushstrokes, angular treatment of shapes and flattened perspective in this colourful, rugged
landscape reveal the influence of Post-Impressionist painter Paul Cézanne. Roger Fry is chiefly remembered
as an art critic, and in that role he exerted a huge influence on British taste of his day. He introduced the
work of Gauguin, Cézanne, Van Gogh and Matisse to Britain under the title 'Post-Impressionists' through two
exhibitions arranged by him in 1910 and 1912.

M	T	W	T	F	S	S
1	2	3	4	5	6	7
8	9	10	11	12	13	14
15	16	17	18	19	20	21
22	23	24	25	26	27	28
29	30	1	2	3	4	5

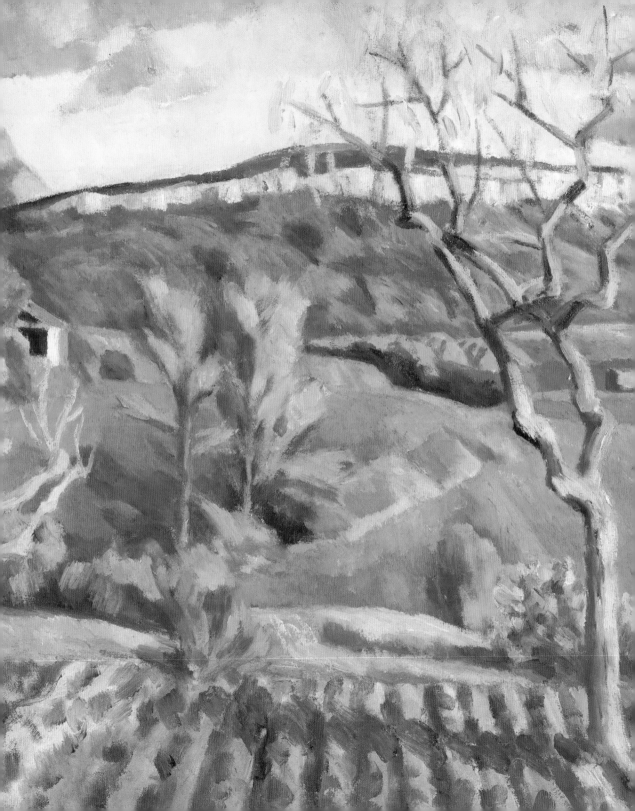

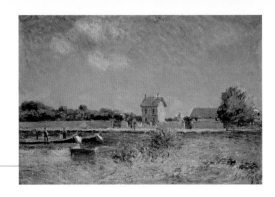

6 Monday · Luan
Bank Holiday (RoI and NI)

7 Tuesday · Máirt

8 Wednesday · Céadaoin

9 Thursday · Déardaoin

10 Friday · Aoine

11 Saturday · Satharn

12 Sunday · Domhnach

Alfred Sisley, *The Banks of the Canal du Loing at Saint-Mammès,* **1888**

Saint-Mammès lies at the confluence of the Seine and Loing rivers, with the canal running parallel to the Loing. Sisley painted a series of views at Saint-Mammès, featuring the cluster of houses beside the lock at the mouth of the canal. The expanse of sky is smooth, the buildings and colourful barges are clearly delineated, while long, thick strokes of pigment are used to convey the reeds and foliage in the foreground.

M	T	W	T	F	S	S
29	30	1	2	3	4	5
6	7	8	9	10	11	12
13	14	15	16	17	18	19
20	21	22	23	24	25	26
27	28	29	30	31	1	2

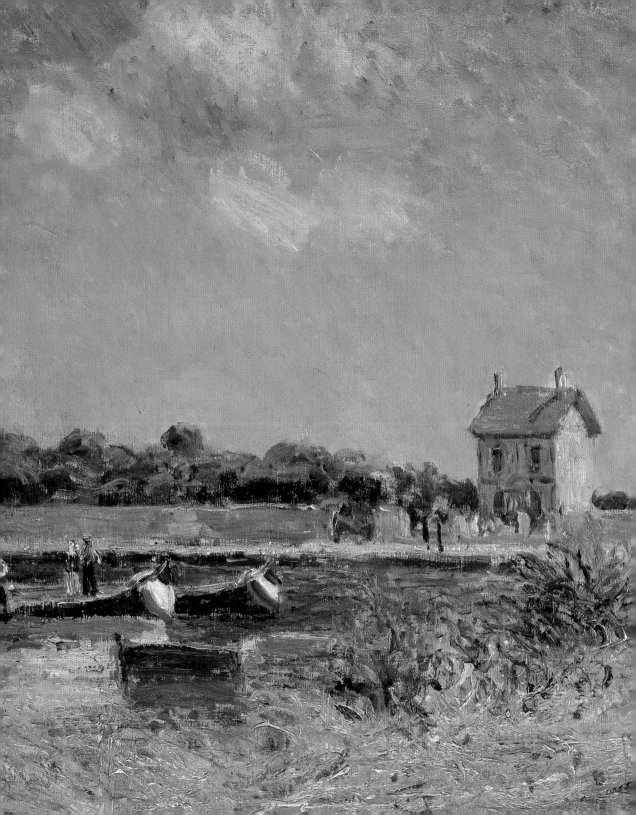

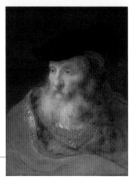

13 Monday · Luan

14 Tuesday · Máirt

15 Wednesday · Céadaoin

16 Thursday · Déardaoin

17 Friday · Aoine

18 Saturday · Satharn

19 Sunday · Domhnach

Govaert Flinck, *Head of an Old Man,* **c.1642**

Flinck studied in Amsterdam with Rembrandt, whose influence is apparent in the realistic treatment of this man's face. The warm colouring, concentrated light source and close-up viewpoint all draw our attention to the finer details of the sitter's features, beard and costume. He wears a gilt-edged cloak, beret and gold chain with medallion. Such chains were used by Rembrandt and Flinck as dress accessories in their portraits and do not necessarily have any symbolic significance.

M	T	W	T	F	S	S
29	30	1	2	3	4	5
6	7	8	9	10	11	12
13	14	15	16	17	18	19
20	21	22	23	24	25	26
27	28	29	30	31	1	2

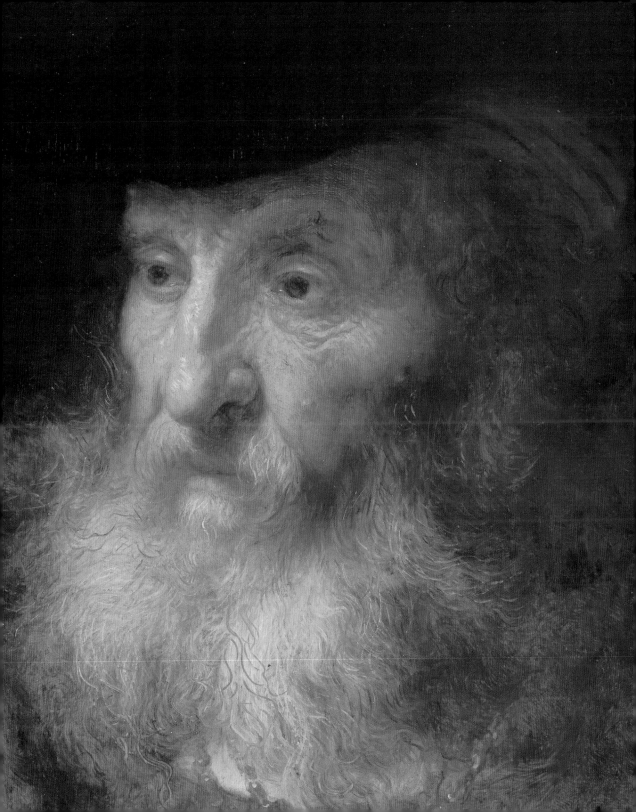

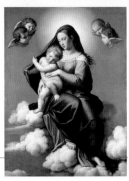

20 Monday · Luan

21 Tuesday · Máirt

22 Wednesday · Céadaoin

23 Thursday · Déardaoin

24 Friday · Aoine

25 Saturday · Satharn

26 Sunday · Domhnach

Sassoferrato, *Madonna and Child Seated in Clouds,* **1650s**

Sassoferrato's art is characterised by a brilliant palette of saturated, translucent colours, together with a polished beauty and a purity of modelling. With the exception of the four charming cherubs at the top, the composition of this picture is derived from Raphael's famous *Madonna of Foligno,* now in the Pinacoteca Vaticana. During his long career, Sassoferrato painted numerous images of refined, classical Madonnas under the influence of Raphael and Annibale Carracci.

M	T	W	T	F	S	S
29	30	1	2	3	4	5
6	7	8	9	10	11	12
13	14	15	16	17	18	19
20	21	22	23	24	25	26
27	28	29	30	31	1	2

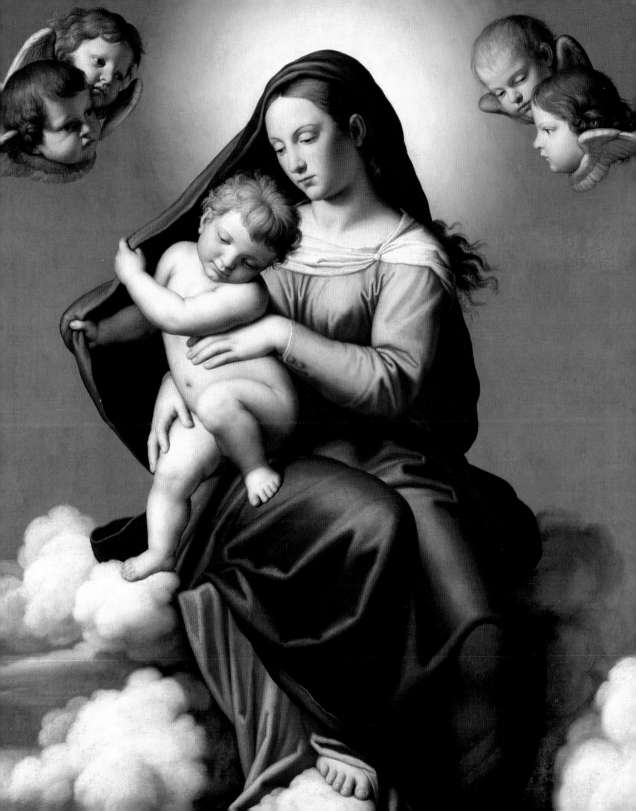

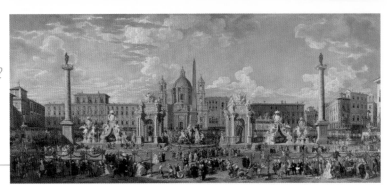

27 Monday · Luan
Spring Bank Holiday (NI)

28 Tuesday · Máirt

29 Wednesday · Céadaoin

30 Thursday · Déardaoin

31 Friday · Aoine

1 Saturday · Satharn

June · Meitheamh

2 Sunday · Domhnach

Giovanni Paolo Panini, *Preparations to Celebrate the Birth of the Dauphin of France in the Piazza Navona,* **1731**

Panini was the most famous painter of Roman 'vedute' (views) during the 18th century. One of his patrons was Cardinal Mechior de Polignac, the French Ambassador to the Holy See. After the birth of the Dauphin, heir of the King of France, the Cardinal marked the event with 10 days of festivities in Rome, culminating with a fireworks display in the Piazza Navona. He commissioned Panini to create two large views of the preparations, of which this is one.

M	T	W	T	F	S	S
29	30	1	2	3	4	5
6	7	8	9	10	11	12
13	14	15	16	17	18	19
20	21	22	23	24	25	26
27	28	29	30	31	1	2

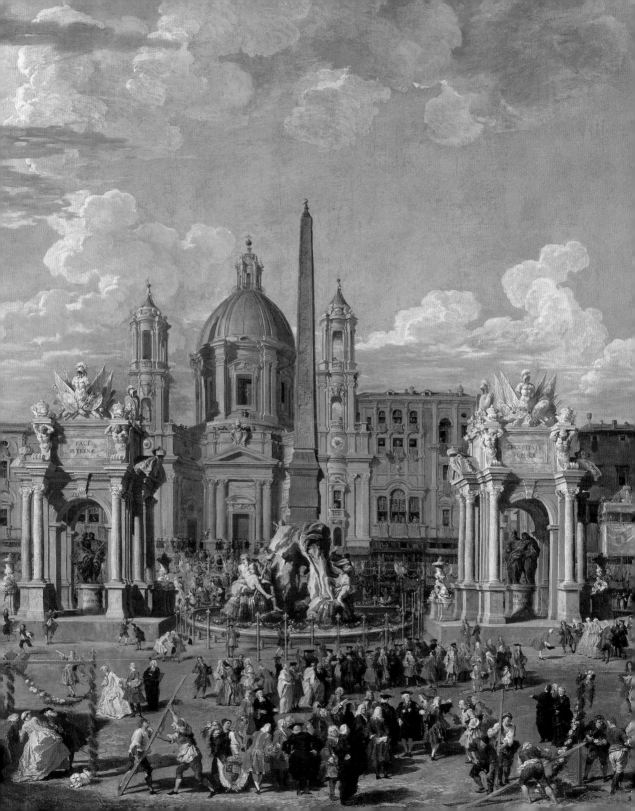

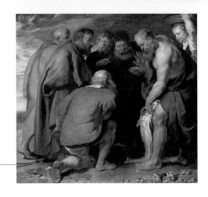

3 Monday · Luan
Bank Holiday (Rol and NI)

4 Tuesday · Máirt

5 Wednesday · Céadaoin

6 Thursday · Déardaoin

7 Friday · Aoine

8 Saturday · Satharn

9 Sunday · Domhnach

Peter Paul Rubens, *Saint Peter Finding the Tribute Money,* **1617–18**

In St Matthew's Gospel, Christ tells Peter he will find money needed for taxes in the jaws of fish. The subject
may have been commissioned by the fishermen's guild. The loose folds of the drapery, the rugged naturalism
of the figures, the powerful anatomy and the strong lighting support Rubens' claim that this picture was
painted by himself rather than by a workshop assistant, as was often the case by 1618.

M	T	W	T	F	S	S
27	28	29	30	31	1	2
3	4	5	6	7	8	9
10	11	12	13	14	15	16
17	18	19	20	21	22	23
24	25	26	27	28	29	30

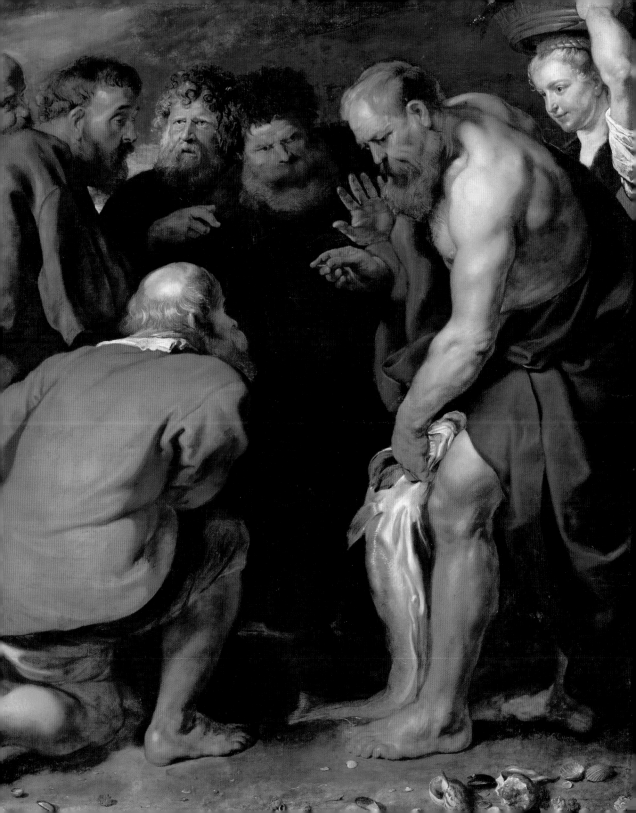

June · Meitheamh
Week 24 · Seachtain 24

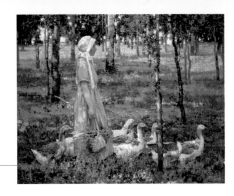

10 Monday · Luan

11 Tuesday · Máirt

12 Wednesday · Céadaoin

13 Thursday · Déardaoin

14 Friday · Aoine

15 Saturday · Satharn

16 Sunday · Domhnach

Stanley Royle, *The Goose Girl,* **c.1921**

This work belongs to a series of pictures with woodland settings painted by Royle around his native Sheffield. His wife, Lily, posed as the girl moving her geese through a bluebell wood in spring. Her lack of expression and the frieze-like composition contribute to the sense of a frozen moment. The flowers' purple hues complement the girl's orange dress, on which the sunlight is reflected. The paint is thickly applied, revealing the influence of French Impressionism.

M	T	W	T	F	S	S
27	28	29	30	31	1	2
3	4	5	6	7	8	9
10	11	12	13	14	15	16
17	18	19	20	21	22	23
24	25	26	27	28	29	30

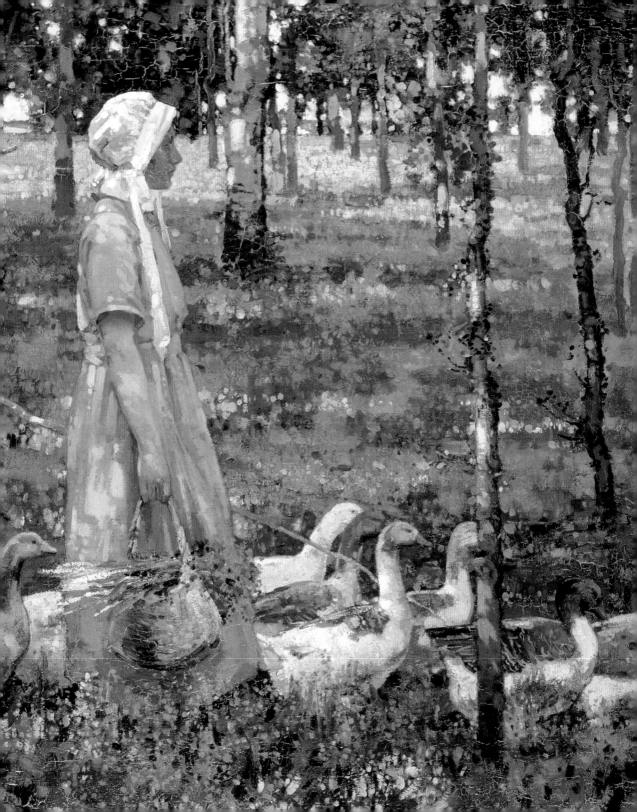

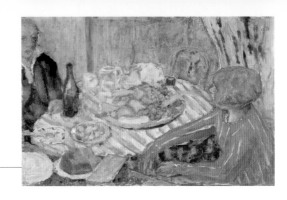

17 Monday · Luan

18 Tuesday · Máirt

19 Wednesday · Céadaoin

20 Thursday · Déardaoin

21 Friday · Aoine

22 Saturday · Satharn

23 Sunday · Domhnach

Pierre Bonnard, *Le Déjeuner,* **1923**

This painting is set in Bonnard's country house 'Ma Roulotte' (My Caravan) in the Seine valley, where he often painted informal family mealtimes. He sits opposite his partner Marthe de Méligny, whom he married in 1925. Between them are the remains of their lunch, seemingly floating on a tilted tabletop, its perspective distorted. Bonnard enjoyed juxtaposing contrasting patterns, as in Marthe's vivid red striped shirt and the blue and white striped tablecloth.

M	T	W	T	F	S	S
27	28	29	30	31	1	2
3	4	5	6	7	8	9
10	11	12	13	14	15	16
17	18	19	20	21	22	23
24	25	26	27	28	29	30

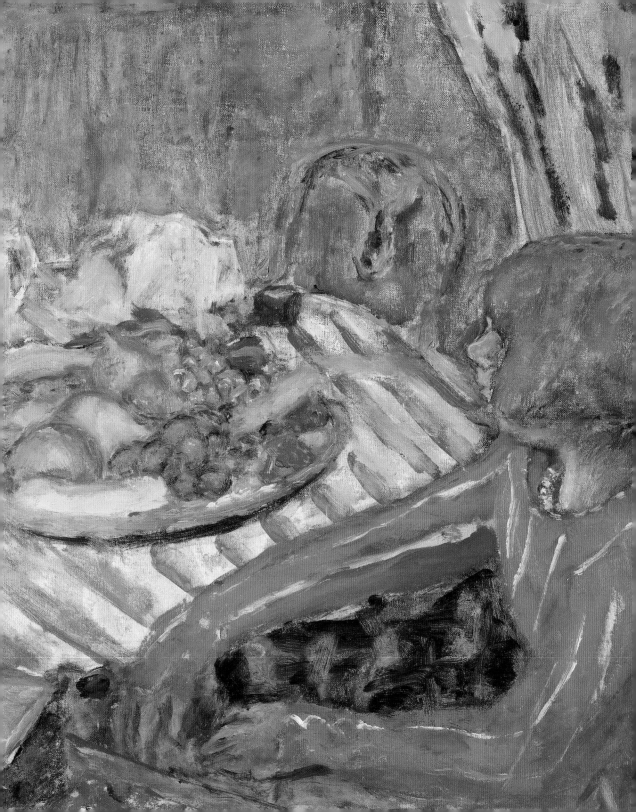

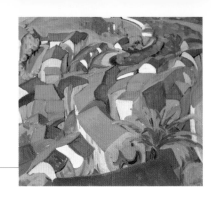

24 Monday · Luan

25 Tuesday · Máirt

26 Wednesday · Céadaoin

27 Thursday · Déardaoin

28 Friday · Aoine

29 Saturday · Satharn *Grand Canal - 7.30 p.m.*

30 Sunday · Domhnach

Mary Swanzy, *Pattern of Rooftops, Czechoslovakia,* **1919–20**

In 1919–20 Mary Swanzy visited Yugoslavia and Czechoslovakia where her sister was doing relief work at the Protestant Mission. Among her favourite Balkan subjects from this trip were colourful scenes of village rooftops and mountain landscapes. Seen from above, these glowing red rooftops tilt up and form curving lines, which lead the eye into the distance. Several houses are windowless, distorted blocks in the manner of Paul Cézanne, whose work Swanzy had studied in Paris.

M	T	W	T	F	S	S
27	28	29	30	31	1	2
3	4	5	6	7	8	9
10	11	12	13	14	15	16
17	18	19	20	21	22	23
24	25	26	27	28	29	30

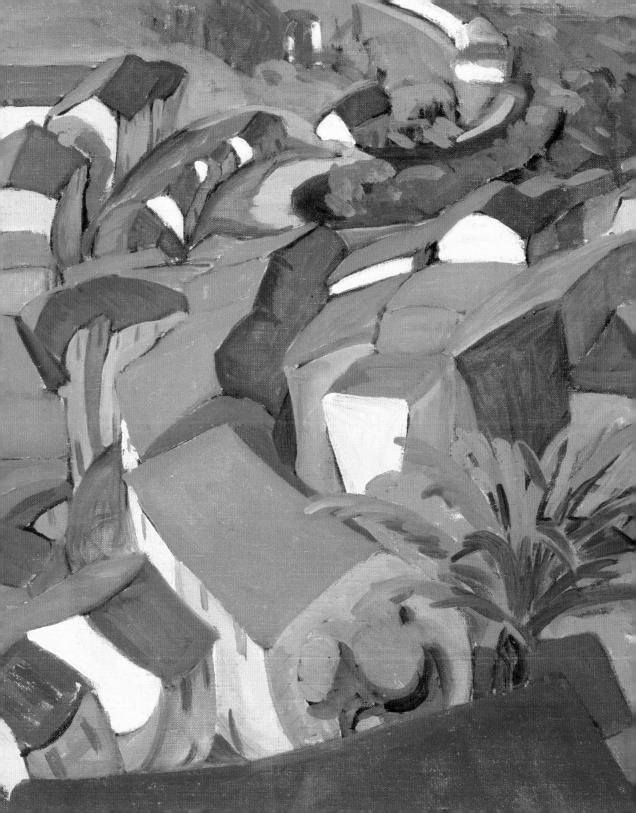

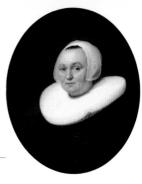

1 Monday · Luan

2 Tuesday · Máirt

3 Wednesday · Céadaoin

4 Thursday · Déardaoin

5 Friday · Aoine

6 Saturday · Satharn

7 Sunday · Domhnach

Bartholomeus van der Helst, *Portrait of a Lady Aged 54,* **1647**

From the mid–1640s to 1670, Van der Helst was the leading portrait painter in Amsterdam. Although he was influenced by Rembrandt and Hals, it was widely believed at the time that he surpassed these masters as a portrait painter. He created realistic and slightly flattering likenesses of his sitters, arranged them in tasteful poses and depicted their fashionable clothes with flair. This middle-aged woman wears a black silk dress, a white cap and a large, finely pleated neck ruff.

M	T	W	T	F	S	S
1	2	3	4	5	6	7
8	9	10	11	12	13	14
15	16	17	18	19	20	21
22	23	24	25	26	27	28
29	30	31	1	2	3	4

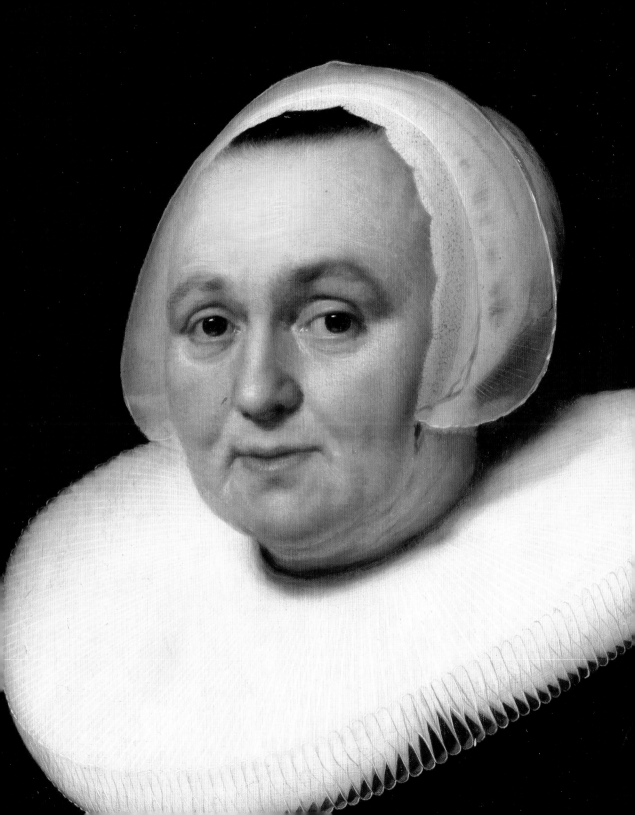

8 Monday · Luan

9 Tuesday · Máirt

10 Wednesday · Céadaoin

11 Thursday · Déardaoin

12 Friday · Aoine

13 Saturday · Satharn

14 Sunday · Domhnach

Jean Baptiste Edouard Detaille, *A Cavalry Officer,* **1887**

Detaille specialised in French military painting, depicting scenes from the Napoleonic era, the Restoration and the Franco-Prussian war with naturalism and attention to detail. Having served as a sub-lieutenant in the 20th Infantry Batallion, he gained first-hand knowledge of soldiers' and cavalry officers' uniforms, which he later painted with great accuracy. This painting shows an officer from the French Restoration, wearing the uniform of the fifth or sixth regiment of dragoons dating from c.1822.

M	T	W	T	F	S	S
1	2	3	4	5	6	7
8	9	10	11	12	13	14
15	16	17	18	19	20	21
22	23	24	25	26	27	28
29	30	31	1	2	3	4

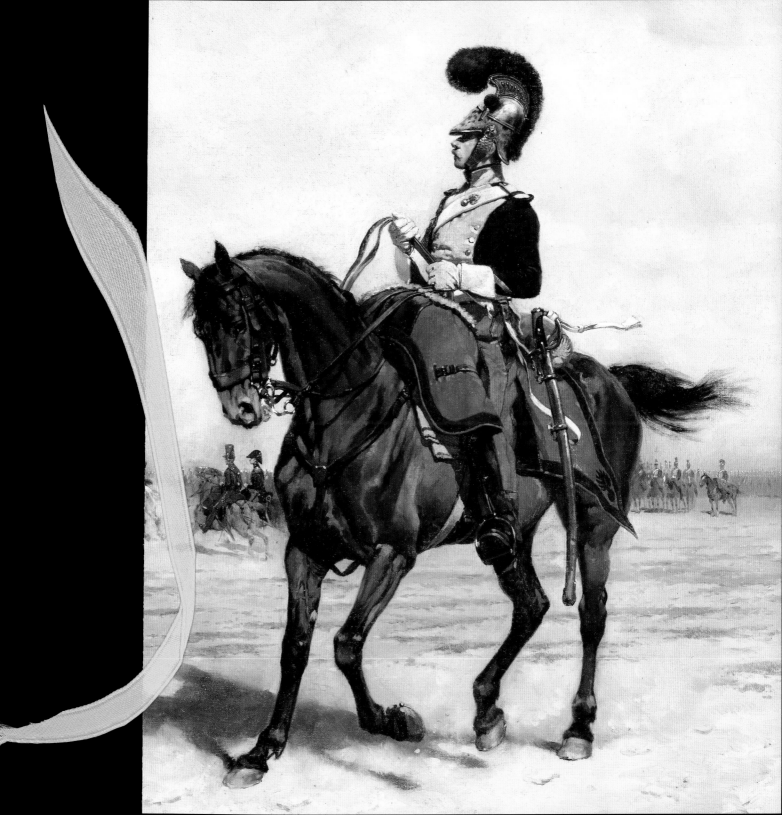

15 Monday · Luan 02 ⌐ 6.30
m. Bubbke '

16 Tuesday · Máirt

17 Wednesday · Céadaoin

18 Thursday · Déardaoin

19 Friday · Aoine

20 Saturday · Satharn

21 Sunday · Domhnach

Francesco Guardi, *The Doge Wedding the Adriatic,* **c.1780**

Guardi specialised in 'vedute' (views) of Venice and the Veneto as well as 'capricci' (imaginary scenes).
Each year on Ascension Day, the gilded state barge, *Il Bucintoro*, rowed the Doge out to the mouth of
the Lido. He threw a gold ring, blessed by the Patriarch of Venice, into the sea, commemorating Venetian
defence of the papacy against Frederick Barbarossa in 1178. In that year, Pope Alexander III had given a
gold ring to the Doge.

M	T	W	T	F	S	S
1	2	3	4	5	6	7
8	9	10	11	12	13	14
15	16	17	18	19	20	21
22	23	24	25	26	27	28
29	30	31	1	2	3	4

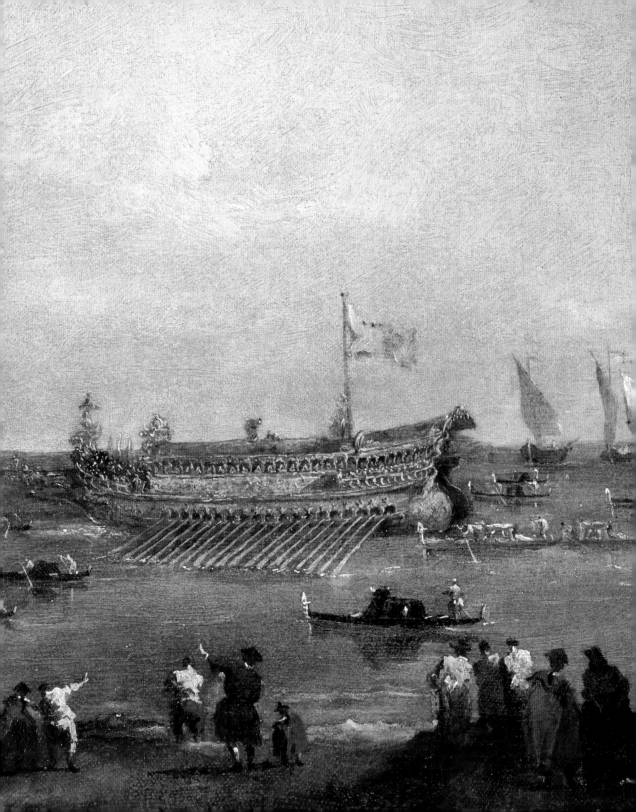

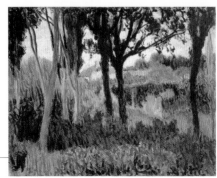

22 Monday · Luan

23 Tuesday · Máirt

24 Wednesday · Céadaoin

25 Thursday · Déardaoin

26 Friday · Aoine

27 Saturday · Satharn

28 Sunday · Domhnach

Roderic O'Conor, *The Farm at Lezaven, Finistère,* **1894**

O'Conor spent over a decade in the Breton village of Pont Aven, coming under the influence of Post-Impressionist painter Paul Gauguin. O'Conor and Gauguin became friends, and both artists used the farmhouse in the background of this scene as a studio. Our eye is led to this building by overlapping layers of vividly coloured flowers, trees and foliage, rendered in striped brushwork that reveals the influence of fellow Post-Impressionist Vincent Van Gogh.

M	T	W	T	F	S	S
1	2	3	4	5	6	7
8	9	10	11	12	13	14
15	16	17	18	19	20	21
22	23	24	25	26	27	28
29	30	31	1	2	3	4

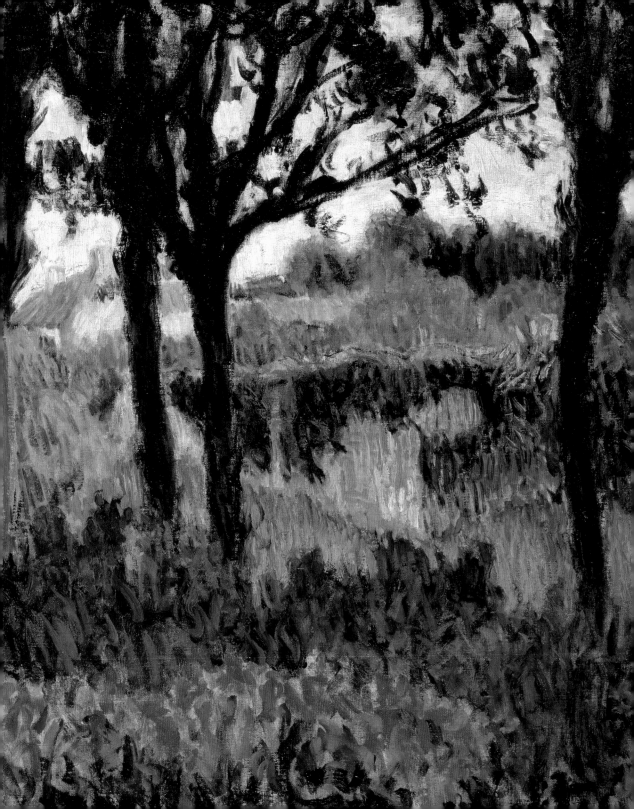

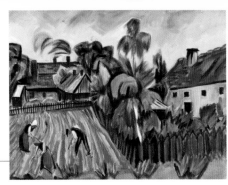

July · Iúil
Week 31 · Seachtain 31

29 Monday · Luan

30 Tuesday · Máirt

31 Wednesday · Céadaoin

1 Thursday · Déardaoin August · Lúnasa

2 Friday · Aoine

3 Saturday · Satharn

4 Sunday · Domhnach

Hermann Max Pechstein, *Houses with Gardens,* **1920**

Pechstein developed a naïve, primitive and angular style of painting evident in his treatment of the peasant folk working the land in this image of rural labour. He was a member of the German Expressionist group 'Die Brücke' (The Bridge), who were influenced by the vivid colours of the French 'Fauve' painters. The complementary green and red hues in the furrows of the field, the rooftops and the trees in this picture intensify each other greatly.

M	T	W	T	F	S	S
1	2	3	4	5	6	7
8	9	10	11	12	13	14
15	16	17	18	19	20	21
22	23	24	25	26	27	28
29	30	31	1	2	3	4

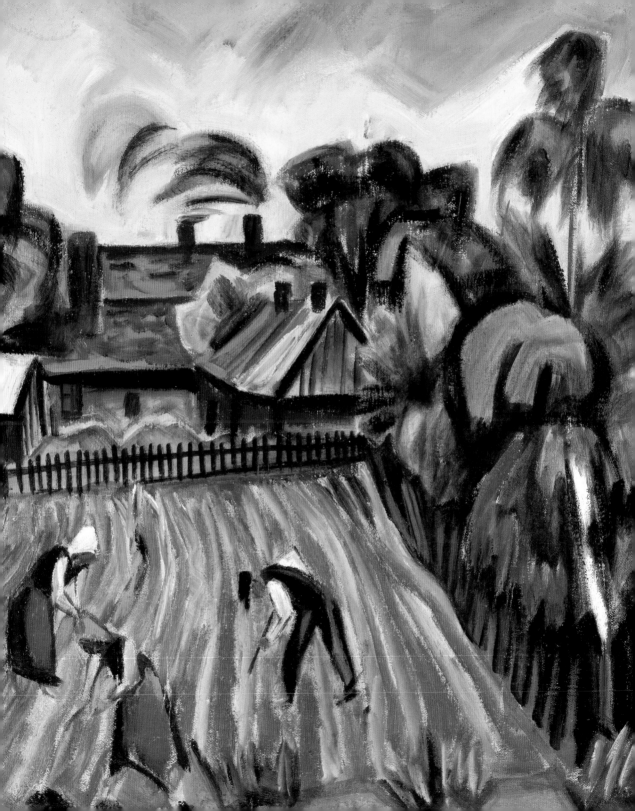

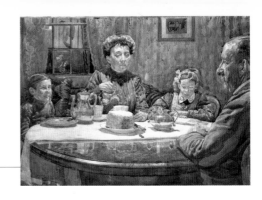

5 Monday · Luan
Bank Holiday (RoI)

6 Tuesday · Máirt

7 Wednesday · Céadaoin

8 Thursday · Déardaoin

9 Friday · Aoine

10 Saturday · Satharn

11 Sunday · Domhnach

Patrick Tuohy, *Supper Time,* **c.1912**

With this watercolour, created at age 18, Tuohy won the Taylor Scholarship. Despite the appearance of a family gathering, all is not what it seems. A woman pours from a silver milk jug in a ritualistic manner, but the man does not have a place setting, and the tablecloth has been laid so as to exclude him from the meal. The man's face is reflected in the window, and Tuohy invests the scene with tension.

M	T	W	T	F	S	S
29	30	31	1	2	3	4
5	6	7	8	9	10	11
12	13	14	15	16	17	18
19	20	21	22	23	24	25
26	27	28	29	30	31	1

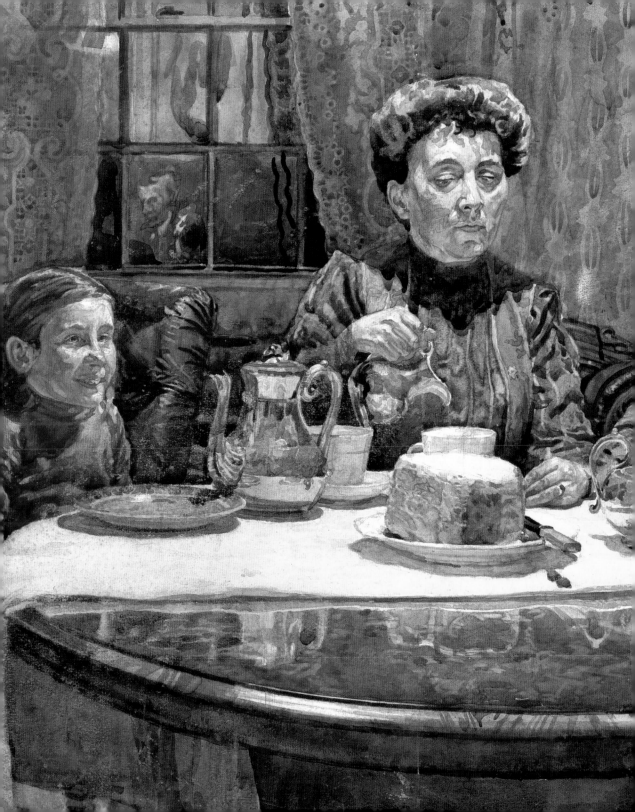

12 Monday · Luan

13 Tuesday · Máirt

14 Wednesday · Céadaoin

15 Thursday · Déardaoin

16 Friday · Aoine

17 Saturday · Satharn

18 Sunday · Domhnach

Mary Delany, *Swift and Swans Island in the Garden of Delville,* **Dublin, 1745**

This fine drawing of the artist's garden in Glasnevin, north Dublin, belongs to an album of 91 works in pencil, pen and wash depicting Dublin suburban scenes as well as houses and gardens in England. These drawings are simple, charming and unpretentious. Mrs Delany's major work, the *Hortus Siceus* or *Flora*, for which she made one thousand flowers from tiny pieces of mosaic paper, was executed when she was between 72 and 82 years old.

M	T	W	T	F	S	S
29	30	31	1	2	3	4
5	6	7	8	9	10	11
12	13	14	15	16	17	18
19	20	21	22	23	24	25
26	27	28	29	30	31	1

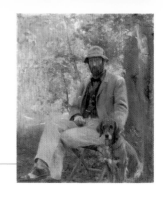

19 Monday · Luan

20 Tuesday · Máirt

21 Wednesday · Céadaoin

22 Thursday · Déardaoin

23 Friday · Aoine

24 Saturday · Satharn

25 Sunday · Domhnach

Walter Frederick Osborne, *Portrait of J.B.S. MacIlwaine, Artist and Inventor,* **1892**

J.B.S. MacIlwaine was a classmate of Osborne at the RHA art school in Dublin. They became lifelong friends and in the 1890s Osborne often took the train from Harcourt Street to Foxrock, where MacIlwaine lived, to visit him and paint outdoors. This portrait was almost certainly painted in MacIlwaine's garden. It belongs to a series of scenes of figures seated under trees through which dappled light falls, in which Osborne adopted an Impressionist technique.

M	T	W	T	F	S	S
29	30	31	1	2	3	4
5	6	7	8	9	10	11
12	13	14	15	16	17	18
19	20	21	22	23	24	25
26	27	28	29	30	31	1

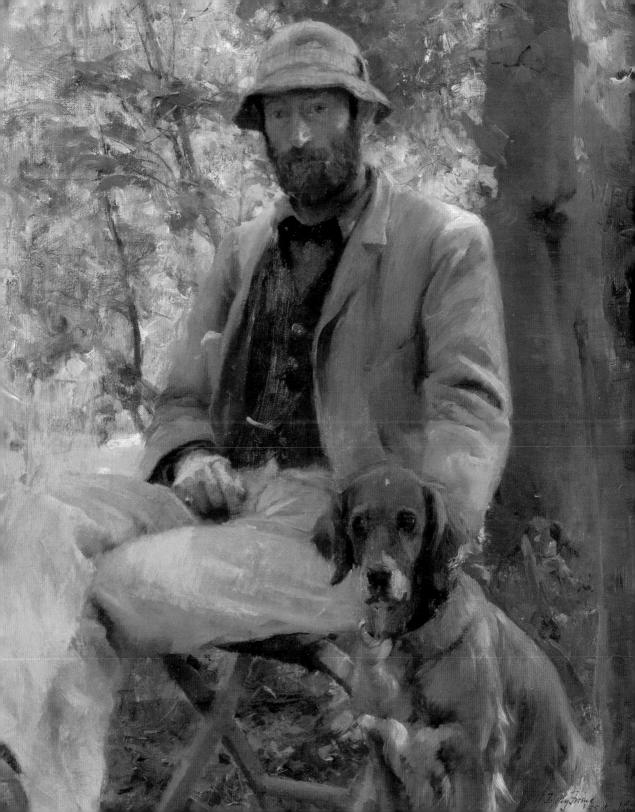

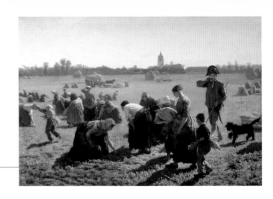

26 Monday · Luan
Summer Bank Holiday (NI)

27 Tuesday · Máirt

28 Wednesday · Céadaoin

29 Thursday · Déardaoin

30 Friday · Aoine

31 Saturday · Satharn

1 Sunday · Domhnach September · Meán Fómhair

Jules Breton, *The Gleaners,* **1854**

In the 1850s, gleaning, the gathering of wheat left after harvesting, was strictly regulated: it had to be done by hand, by women and young children, in non-enclosed fields, and between dawn and dusk. Breton saw nobility in the toil of the gleaners, who work in the heat of the midday sun, yet the overall atmosphere is not one of hardship, but of quiet labour. Breton's native village of Courrières is depicted in the distance.

M	T	W	T	F	S	S
29	30	31	1	2	3	4
5	6	7	8	9	10	11
12	13	14	15	16	17	18
19	20	21	22	23	24	25
26	27	28	29	30	31	1

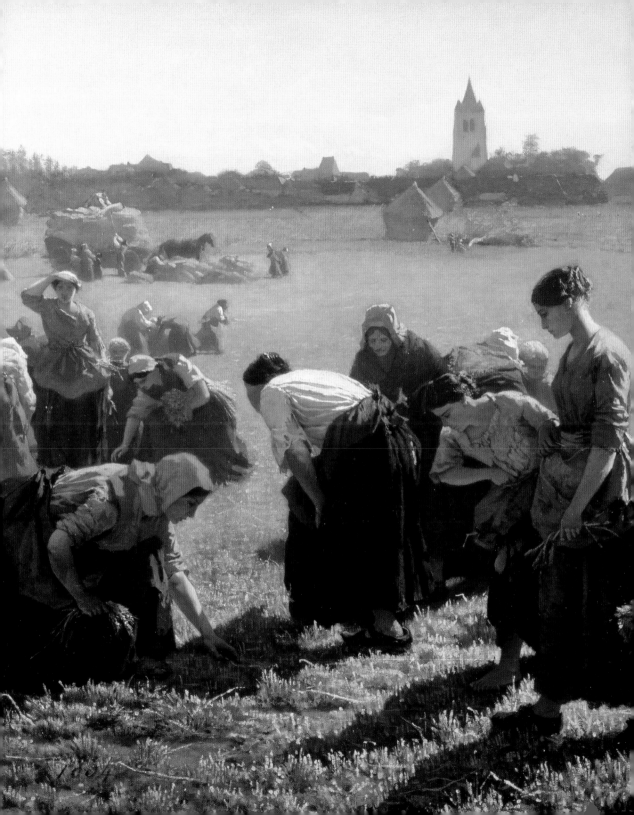

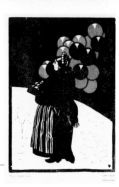

2 Monday · Luan

3 Tuesday · Máirt

4 Wednesday · Céadaoin

5 Thursday · Déardaoin

6 Friday · Aoine

7 Saturday · Satharn

8 Sunday · Domhnach

Erik Lange, *Signs of Spring,* **1920**

In 2005, to coincide with the Gallery's exhibition of Swedish prints 'From Darkness into Light', the Swedish Fine Art Print Society presented a number of portfolios of prints to the collection. Each year, from its foundation in 1895, the Society has published a selection of prints by its members. This dramatic woodcut by Lange appeared in the Society's 1920 portfolio.

M	T	W	T	F	S	S
26	27	28	29	30	31	1
2	3	4	5	6	7	8
9	10	11	12	13	14	15
16	17	18	19	20	21	22
23	24	25	26	27	28	29
30	1	2	3	4	5	6

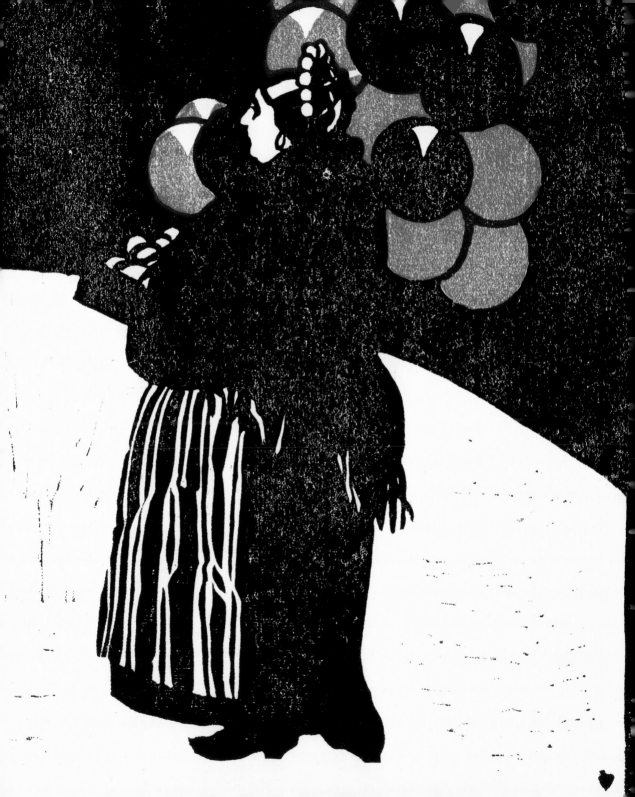

9 Monday · Luan

10 Tuesday · Máirt

11 Wednesday · Céadaoin

12 Thursday · Déardaoin

13 Friday · Aoine

14 Saturday · Satharn

15 Sunday · Domhnach

Harry Clarke, *The Song of the Mad Prince,* **1917**

Clarke's fantastical interpretation of Walter de la Mare's poem shows the distressed prince mourning his dead love at her grave, holding a crucifix-shaped dagger and a fan. Behind him are his parents, the king holding a key, the queen concentrating on her Rosary. Clarke plated a sheet of blue glass against a sheet of ruby glass, and worked both with pen and acid to produce intense colours, intricate patterns and a glittering, jewelled effect.

M	T	W	T	F	S	S
26	27	28	29	30	31	1
2	3	4	5	6	7	8
9	10	11	12	13	14	15
16	17	18	19	20	21	22
23	24	25	26	27	28	29
30	1	2	3	4	5	6

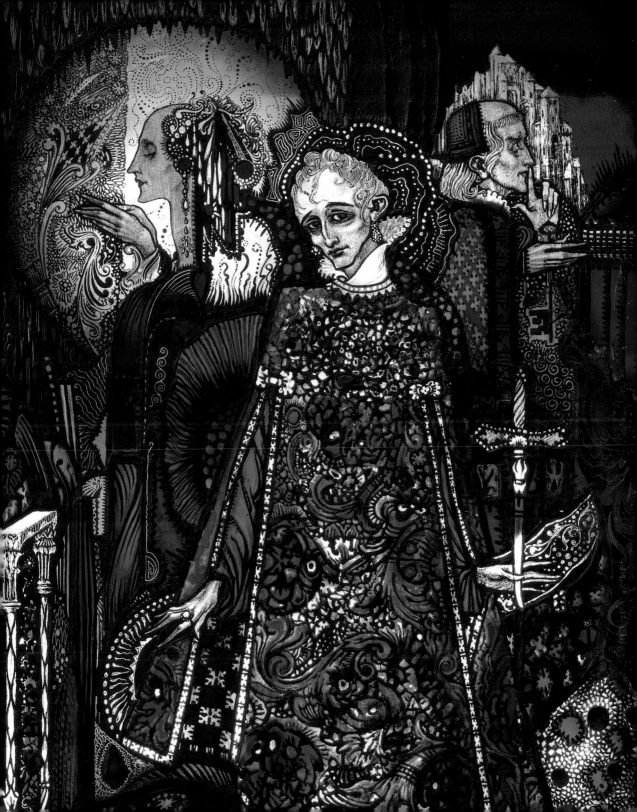

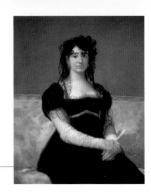

16 Monday · Luan

17 Tuesday · Máirt

18 Wednesday · Céadaoin

19 Thursday · Déardaoin

20 Friday · Aoine

21 Saturday · Satharn

22 Sunday · Domhnach

Francisco José de Goya y Lucientes, *Doña Antonia Zárate,* **c.1805–06**
This lady was a celebrated actress and one of several stage personalities painted by Goya. An enthusiast of the theatre, he counted playwrights, actors and actresses among his friends. He accentuates her dark beauty by setting off her black gown and lace *mantilla* against the yellow damask settee. In her hands she holds a *fleco* (fan), and her arms are covered with white fingerless gloves. Her expression is direct, if slightly melancholic.

M	T	W	T	F	S	S
26	27	28	29	30	31	1
2	3	4	5	6	7	8
9	10	11	12	13	14	15
16	17	18	19	20	21	22
23	24	25	26	27	28	29
30	1	2	3	4	5	6

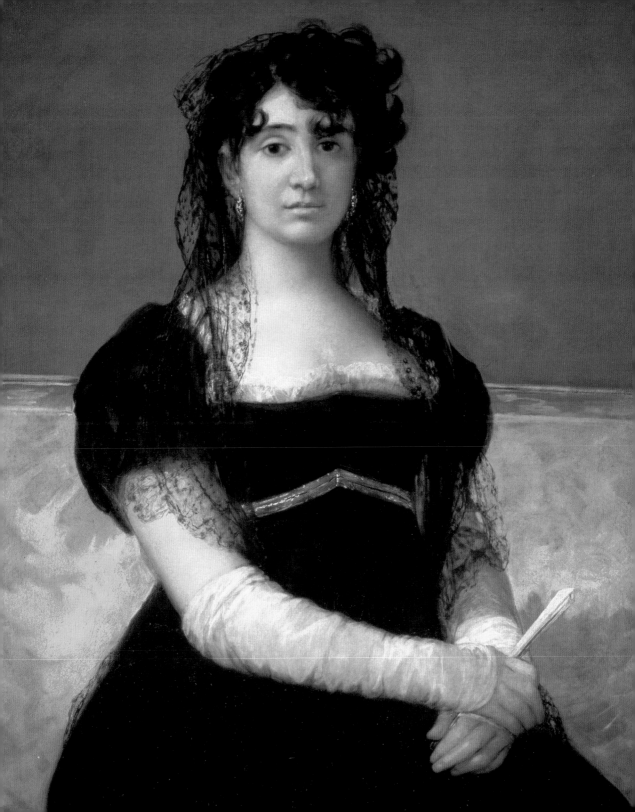

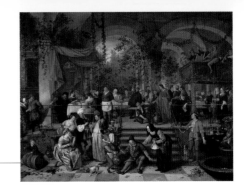

23 Monday · Luan

24 Tuesday · Máirt

25 Wednesday · Céadaoin

26 Thursday · Déardaoin

27 Friday · Aoine

28 Saturday · Satharn

29 Sunday · Domhnach

Jan Steen, *The Marriage Feast at Cana,* **1665–70**
The miracle of Christ turning water into wine at the marriage feast at Cana, told only in St John's Gospel, is featured in this lively inn scene. A drunkard is encouraged to return home by his long-suffering wife, while a young man in orange gestures to the fountain, or water of life. He looks towards Christ, underscoring the true meaning of the miracle, and reminds us that wine should be enjoyed in moderation.

M	T	W	T	F	S	S
26	27	28	29	30	31	1
2	3	4	5	6	7	8
9	10	11	12	13	14	15
16	17	18	19	20	21	22
23	24	25	26	27	28	29
30	1	2	3	4	5	6

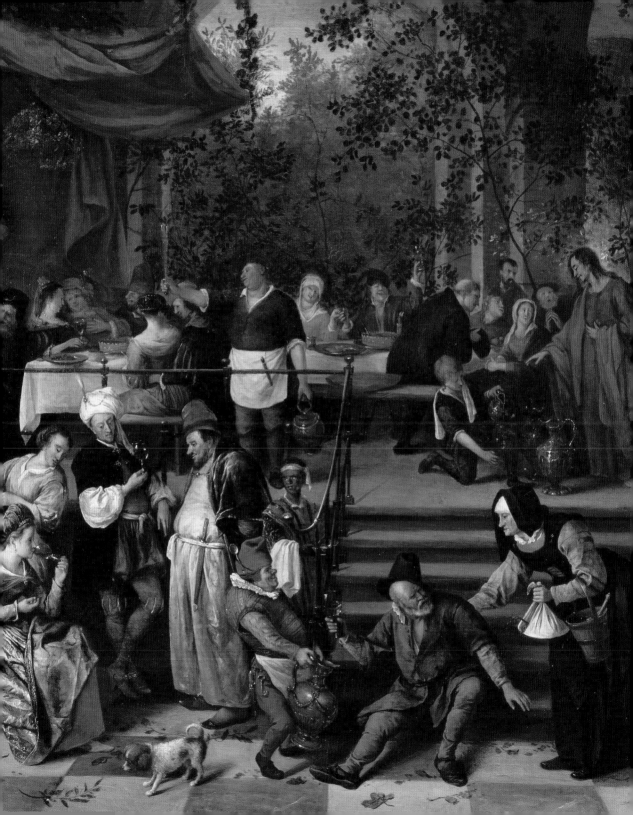

30 Monday · Luan

1 Tuesday · Máirt October · Deireadh Fómhair

2 Wednesday · Céadaoin

3 Thursday · Déardaoin

4 Friday · Aoine

5 Saturday · Satharn

6 Sunday · Domhnach

Willem Drost, *Bust of a Man Wearing a Large-brimmed Hat*, **c.1654**
Drost studied with Rembrandt, becoming a follower of his mature style. This man's fur-lined cloak is similar
to that in Rembrandt's *Self-Portrait aged Thirty-Four* as is the cap, this one embellished with a crab-shaped
brooch and pearl drop. A chain with crucifixes hangs on his chest. This costume was probably a studio prop
used by Rembrandt and his followers. The sensitive handling of the man's eyes and parted lips and the
suffused lighting are highly accomplished.

M	T	W	T	F	S	S
26	27	28	29	30	31	1
2	3	4	5	6	7	8
9	10	11	12	13	14	15
16	17	18	19	20	21	22
23	24	25	26	27	28	29
30	1	2	3	4	5	6

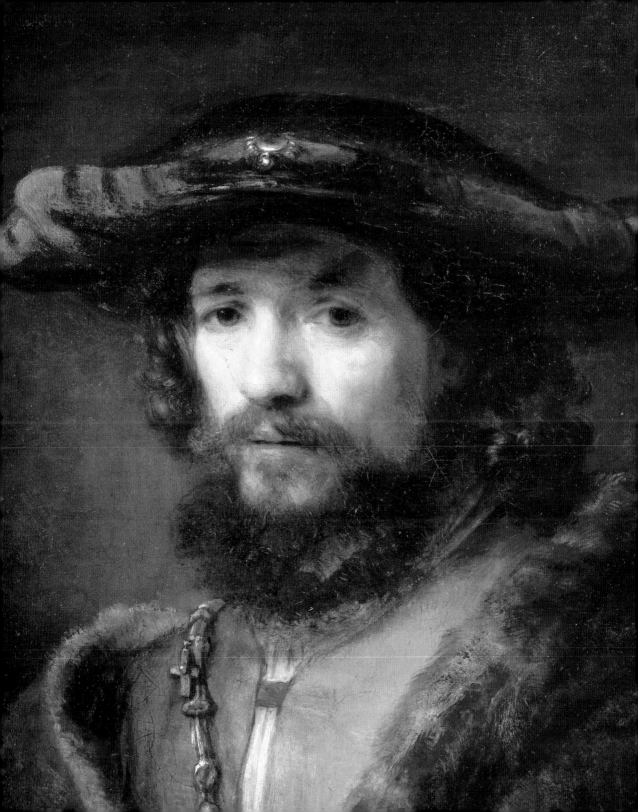

7 Monday · Luan

8 Tuesday · Máirt

9 Wednesday · Céadaoin

10 Thursday · Déardaoin

11 Friday · Aoine

12 Saturday · Satharn

13 Sunday · Domhnach

Ernest Meissonier, *A Group of Cavalry in the Snow: Moreau and Dessoles before Hohenlinden,* **1875**

The French General, Moreau, plans strategies with his Chef d'État, Dessoles, before his victory at Hohenlinden (1800), a critical battle in the Napoleonic campaigns. The men have dismounted their horses and stand on a promontory where one looks through a telescope. Two Hussar troopers hold the closely grouped horses. A cool tonal range suggests the freezing atmosphere, and precise details of the uniforms and animal anatomy provide an accurate record of this important historical event.

M	T	W	T	F	S	S
30	1	2	3	4	5	6
7	8	9	10	11	12	13
14	15	16	17	18	19	20
21	22	23	24	25	26	27
28	29	30	31	1	2	3

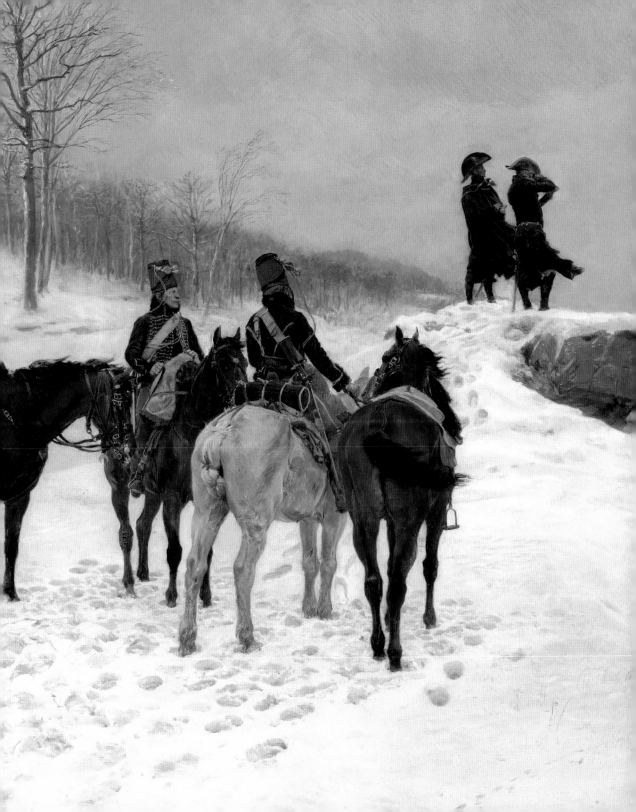

14 Monday · Luan

15 Tuesday · Máirt

16 Wednesday · Céadaoin

17 Thursday · Déardaoin

18 Friday · Aoine

19 Saturday · Satharn

20 Sunday · Domhnach

Jack Hanlon, *Fiery Leaves,* **1935–38**

Though ordained as a priest in 1939, Hanlon was also a dedicated artist, having studied in Paris with the Cubist artist André Lhote. He was also advised by the Fauvist Henri Matisse, and the influence of both modernist artists and their feeling for flat pattern and bright colour is apparent in this cheerful work. Hanlon is best remembered for his watercolours of flowers and foliage, which were executed rapidly, resulting in lively, spontaneous works.

M	T	W	T	F	S	S
30	1	2	3	4	5	6
7	8	9	10	11	12	13
14	15	16	17	18	19	20
21	22	23	24	25	26	27
28	29	30	31	1	2	3

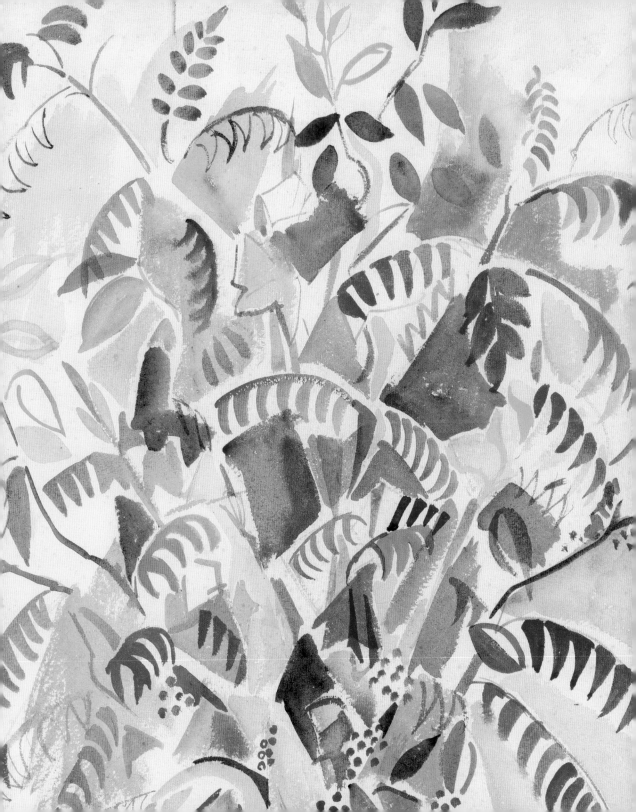

October · Deireadh Fómhair
Week 43 · Seachtain 43

21 Monday · Luan

22 Tuesday · Máirt

23 Wednesday · Céadaoin

24 Thursday · Déardaoin

25 Friday · Aoine

26 Saturday · Satharn

27 Sunday · Domhnach

Vincent Van Gogh, *Rooftops in Paris,* **1886**

Vincent Van Gogh travelled from his native Holland to Paris in early 1886, where he rented an apartment with his brother Theo on the rue Lepic near Montmartre. This bohemian district of Paris afforded panoramic views of the city, and from his window, Vincent painted four views of the rooftops. This painting, one of the aforementioned series, shows the city centre extending south. The thick application of paint evokes a cloudy, overcast sky.

M	T	W	T	F	S	S
30	1	2	3	4	5	6
7	8	9	10	11	12	13
14	15	16	17	18	19	20
21	22	23	24	25	26	27
28	29	30	31	1	2	3

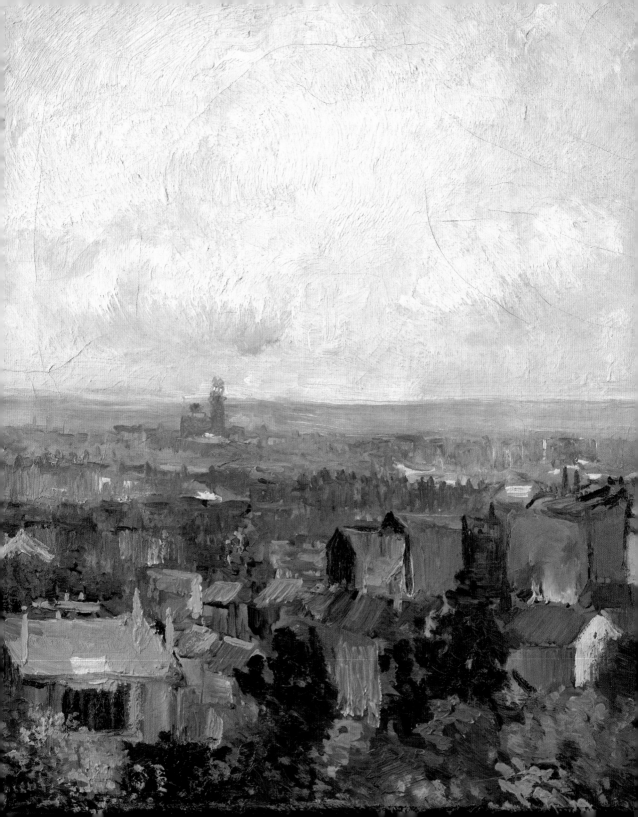

28 Monday · Luan
Bank Holiday (RoI)

29 Tuesday · Máirt

30 Wednesday · Céadaoin

31 Thursday · Déardaoin
Hallowe'en

1 Friday · Aoine November · Samhain

2 Saturday · Satharn

3 Sunday · Domhnach

William Orpen, *Looking at the Sea,* **c.1912**
Orpen holidayed on Howth Head every summer from 1909 until the outbreak of the First World War. He
rented a house called 'The Cliffs', which commanded spectacular views of Dublin Bay, and captured these lazy
days in a series of informal oil paintings. Using an Impressionist technique, Orpen has depicted himself and his
wife, Grace, relaxing under the tent they erected as a wind shelter on the spot where they liked to picnic.

M	T	W	T	F	S	S
30	1	2	3	4	5	6
7	8	9	10	11	12	13
14	15	16	17	18	19	20
21	22	23	24	25	26	27
28	29	30	31	1	2	3

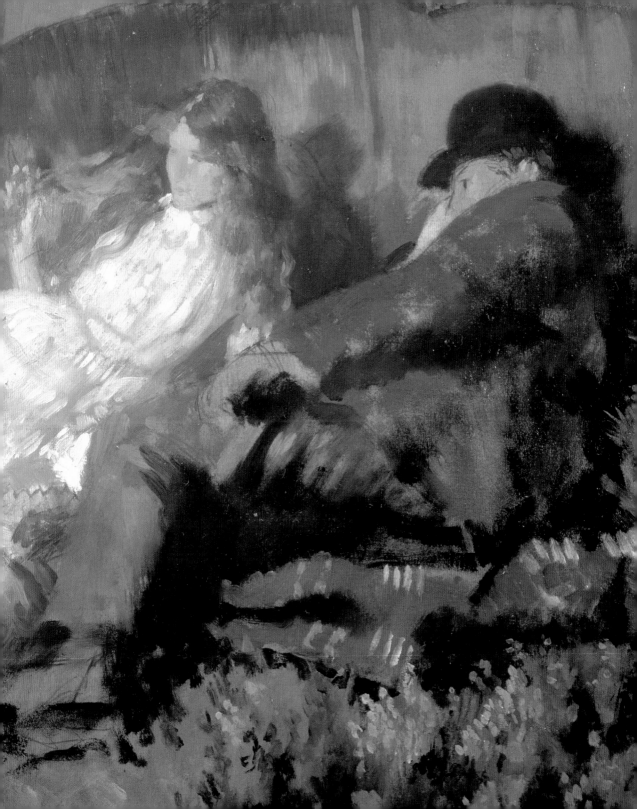

4 Monday · Luan

5 Tuesday · Máirt

6 Wednesday · Céadaoin

7 Thursday · Déardaoin

8 Friday · Aoine

9 Saturday · Satharn

10 Sunday · Domhnach

Camille Pissarro, *Chrysanthemums in a Chinese Vase,* **1873**

Pissarro painted flowers during bouts of bad weather when working outside was not possible. A number of his still-life and flower pieces from 1872–73 feature this delicate floral wallpaper in the background. The pattern of the blue and yellow vase is reflected on the highly polished table, and the casually placed books reinforce the domestic setting of the composition. The brightly coloured chrysanthemums are rendered in short, tight brushstrokes, built up in layers.

M	T	W	T	F	S	S
28	29	30	31	1	2	3
4	5	6	7	8	9	10
11	12	13	14	15	16	17
18	19	20	21	22	23	24
25	26	27	28	29	30	1

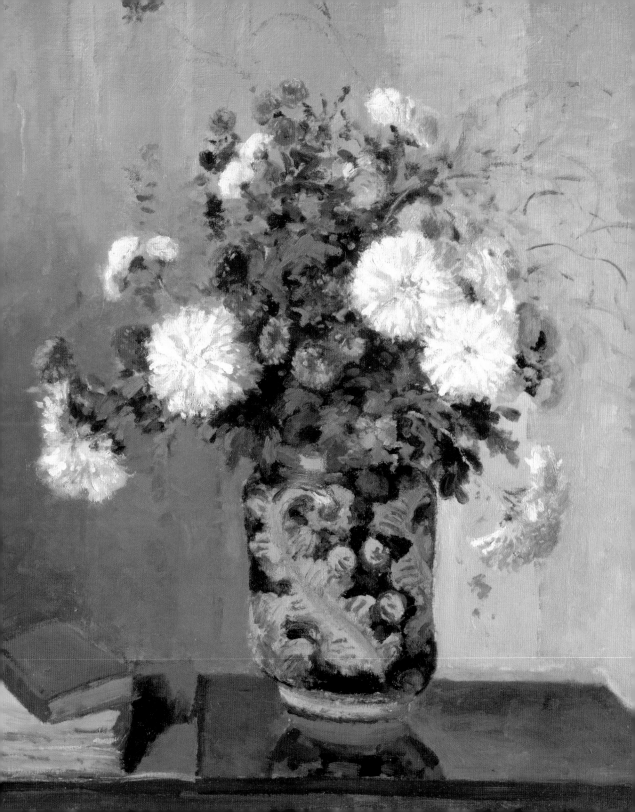

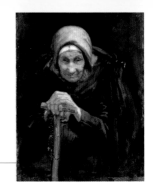

11 Monday · Luan

12 Tuesday · Máirt

13 Wednesday · Céadaoin

14 Thursday · Déardaoin

15 Friday · Aoine

16 Saturday · Satharn

17 Sunday · Domhnach

Helen Mabel Trevor, *The Fisherman's Mother,* **c.1893**

In Brittany, Trevor became interested in the lives of the fishing people, their customs and traditions, particularly those of the women, whose husbands and sons were in constant danger at sea. This aged mother rests on her cane, her hands entwined with rosary beads. Those hands represent a life of hard work endured with a steadfast religious faith. Through piercing eyes, her unflinching gaze reflects the strength of character required of her throughout her life.

M	T	W	T	F	S	S
28	29	30	31	1	2	3
4	5	6	7	8	9	10
11	12	13	14	15	16	17
18	19	20	21	22	23	24
25	26	27	28	29	30	1

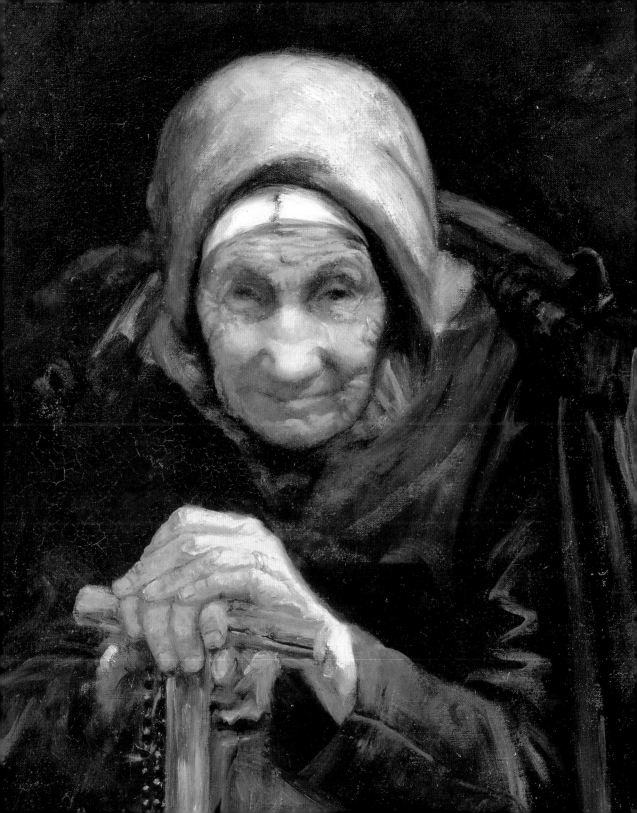

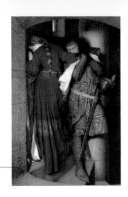

18 Monday · Luan

19 Tuesday · Máirt

20 Wednesday · Céadaoin

21 Thursday · Déardaoin

22 Friday · Aoine

23 Saturday · Satharn

24 Sunday · Domhnach

Frederic William Burton, *Hellelil and Hildebrand, or the Meeting on the Turret Stairs,* **1864**

In the medieval Danish ballad 'Hellelil and Hildebrand', the eponymous lovers' ill-fated romance ends when Hellelil's father discovers it and orders his sons to kill Hildebrand. Burton depicts the moment of the couple's final meeting, before Hildebrand goes to meet his death. Their averted eyes and tender embrace are poignantly conveyed by the artist. Burton's interest in the art and legend of the Middle Ages was shared with the Pre-Raphaelites, whom he knew in London.

M	T	W	T	F	S	S
28	29	30	31	1	2	3
4	5	6	7	8	9	10
11	12	13	14	15	16	17
18	19	20	21	22	23	24
25	26	27	28	29	30	1

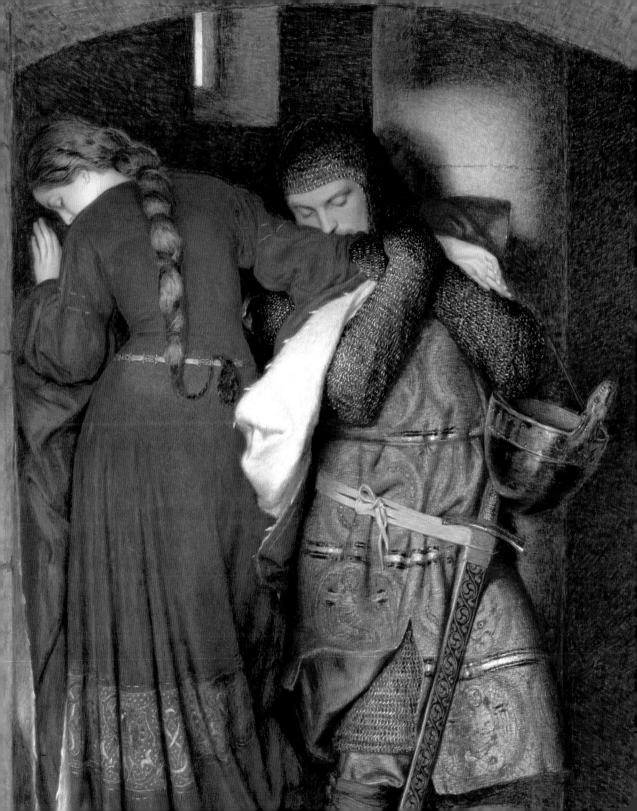

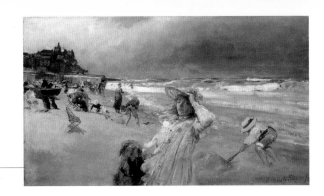

25 Monday · Luan

26 Tuesday · Máirt

27 Wednesday · Céadaoin

28 Thursday · Déardaoin

29 Friday · Aoine

30 Saturday · Satharn

1 Sunday · Domhnach December · Nollaig

Robert Ponsonby Staples, *On the Beach, Broadstairs, Kent,* **1899**

In this delightful painting, we see a familiar day at the seaside. Blustery weather has not deterred people from playing on the beach. A young girl walks her dog, clutching her straw hat with one hand to keep it in place. Nearby, young boys are building sandcastles, while others brave the rolling waves. The sketchiness of Staples' technique perfectly captures the atmosphere. This painting may be the one exhibited as *Our Holiday* in 1901.

M	T	W	T	F	S	S
28	29	30	31	1	2	3
4	5	6	7	8	9	10
11	12	13	14	15	16	17
18	19	20	21	22	23	24
25	26	27	28	29	30	1

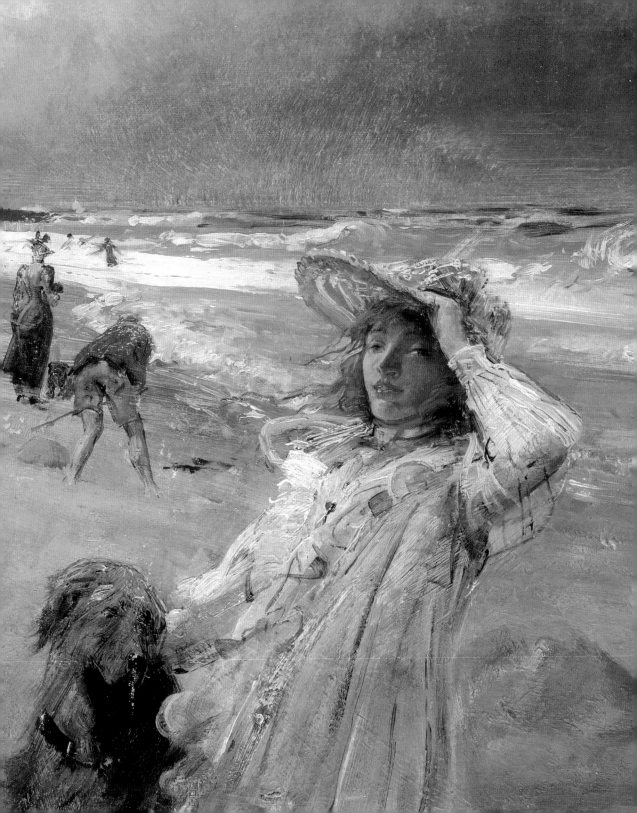

2 Monday · Luan

3 Tuesday · Máirt

4 Wednesday · Céadaoin

5 Thursday · Déardaoin

6 Friday · Aoine

7 Saturday · Satharn

8 Sunday · Domhnach

Jacques Yverni, *The Annunciation,* **c.1435**

Against a gold leaf background, the Archangel Gabriel appears to the Virgin, Her purity symbolised by the lily that stands between them. In the bottom left, the donor of the altarpiece and her tonsured chaplain kneel in prayer, their small size indicative of their humble role. Above, God the Father appears in a celestial sphere, and emanating from the heavenly rays are the dove of the Holy Spirit and a tiny figure of the Christ Child.

M	T	W	T	F	S	S
25	26	27	28	29	30	1
2	3	4	5	6	7	8
9	10	11	12	13	14	15
16	17	18	19	20	21	22
23	24	25	26	27	28	29
30	31	1	2	3	4	5

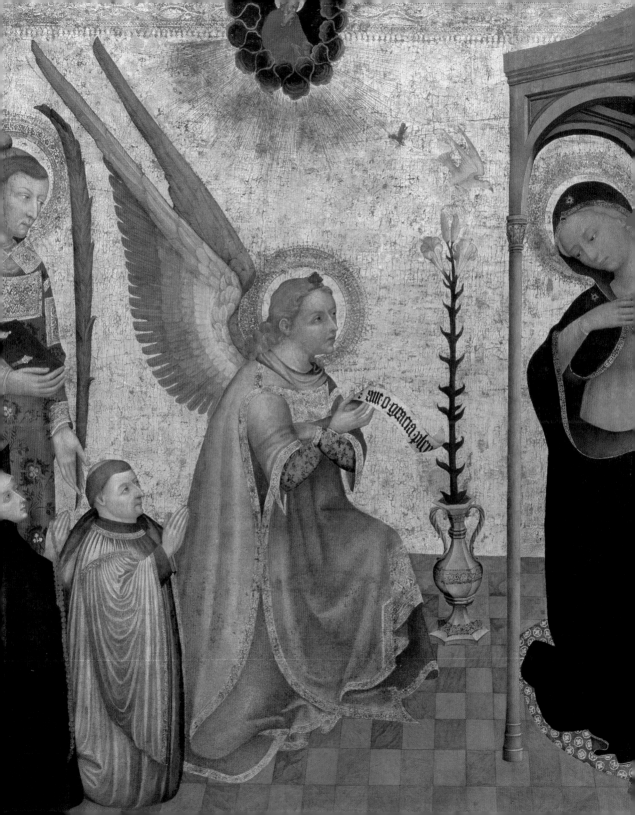

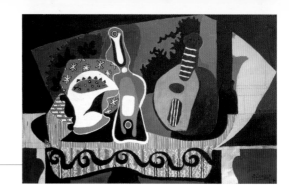

9 Monday · Luan

10 Tuesday · Máirt

11 Wednesday · Céadaoin

12 Thursday · Déardaoin

13 Friday · Aoine

14 Saturday · Satharn

15 Sunday · Domhnach

Pablo Picasso, *Still Life with a Mandolin,* **1924**

Picasso spent the summer of 1924 in Juan-les-Pins on the Mediterranean, and the monumental still lifes he created there show the influence of Matisse in their decorative vitality and flat, vivid colours. A fruit dish (resembling a face in profile), a bottle and a mandolin are arranged on a patterned tablecloth, while bushes and cacti are silhouetted against a nocturnal sky. The forms are reduced to distorted yet identifiable shapes, painted in a bold, rhythmic style.

M	T	W	T	F	S	S
25	26	27	28	29	30	1
2	3	4	5	6	7	8
9	10	11	12	13	14	15
16	17	18	19	20	21	22
23	24	25	26	27	28	29
30	31	1	2	3	4	5

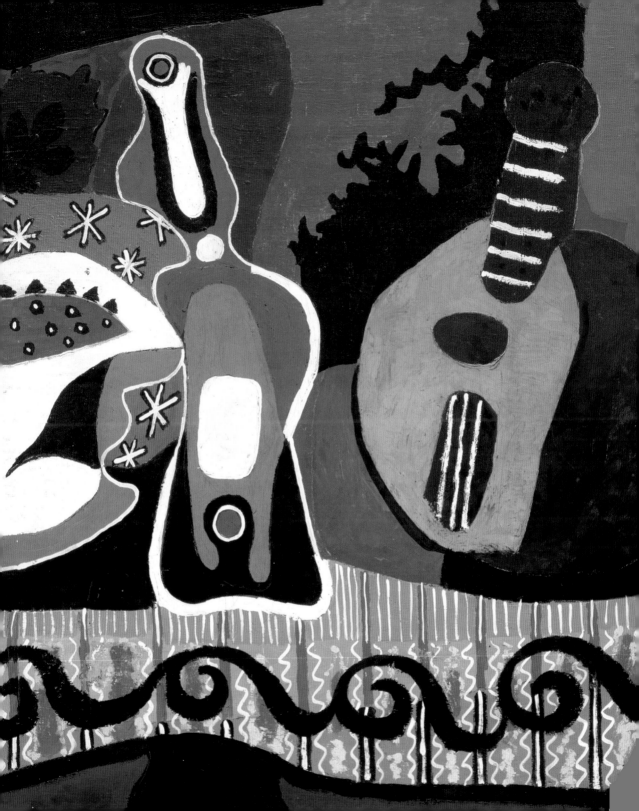

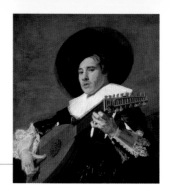

16 Monday · Luan

17 Tuesday · Máirt

18 Wednesday · Céadaoin

19 Thursday · Déardaoin

20 Friday · Aoine

21 Saturday · Satharn

22 Sunday · Domhnach

Frans Hals, *The Lute Player,* **c.1630s**

In Haarlem, Hals specialised in life-size portraits of figures drinking or making music, a theme which is particularly associated with the Dutch followers of Caravaggio. As this fashionably-dressed man plays his lute, he turns towards the viewer with an engaging glance. The obvious *pentimento* in the contour of his hat indicates the artist's change of mind about its shape and position. Despite receiving important portrait commissions throughout his career, Hals was frequently in financial difficulties.

M	T	W	T	F	S	S
25	26	27	28	29	30	1
2	3	4	5	6	7	8
9	10	11	12	13	14	15
16	17	18	19	20	21	22
23	24	25	26	27	28	29
30	31	1	2	3	4	5

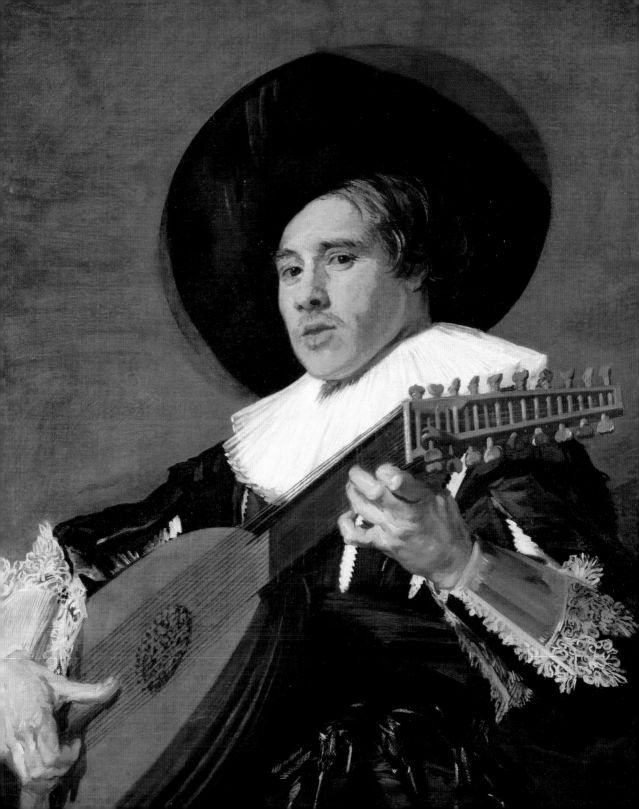

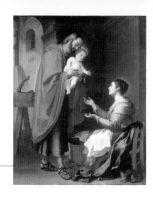

23 Monday · Luan

24 Tuesday · Máirt
Christmas Eve

25 Wednesday · Céadaoin
Christmas Day

26 Thursday · Déardaoin
St Stephen's Day

27 Friday · Aoine

28 Saturday · Satharn

29 Sunday · Domhnach

Bartolomé Esteban Murillo, *The Holy Family,* **c.1650s**

Representations of the Holy Family became highly popular in 17th-century Spain. Murillo depicts this family scene with great tenderness and emphasises their humanity as Mary reaches out her arms to receive the Infant from St Joseph. The work basket at her knee and the cat curled up beside her complete the domestic atmosphere of the scene.

M	T	W	T	F	S	S
25	26	27	28	29	30	1
2	3	4	5	6	7	8
9	10	11	12	13	14	15
16	17	18	19	20	21	22
23	24	25	26	27	28	29
30	31	1	2	3	4	5

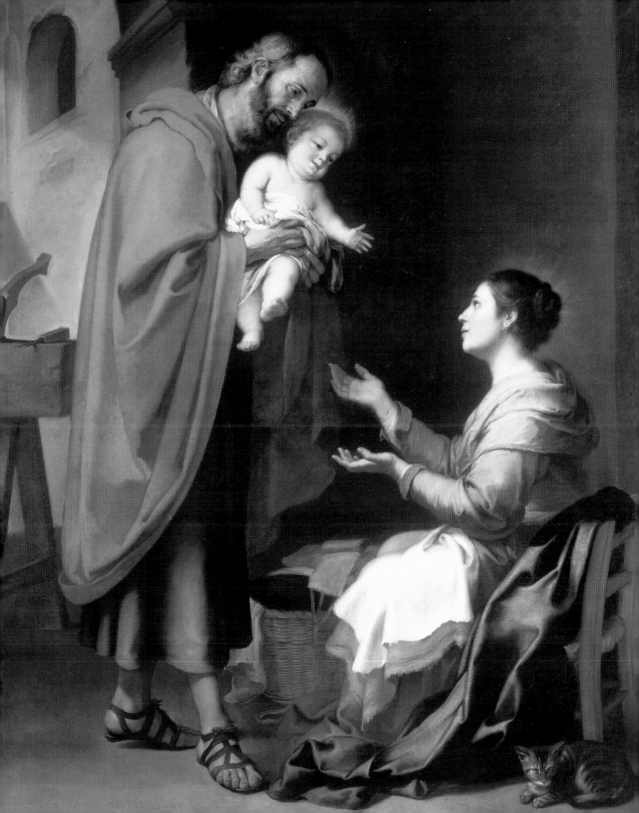

30 Monday · Luan

31 Tuesday · Máirt
New Year's Eve

1 Wednesday · Céadaoin
New Year's Day

2014 January · Eanáir

2 Thursday · Déardaoin

3 Friday · Aoine

4 Saturday · Satharn

5 Sunday · Domhnach

Paul Henry, *Launching the Currach,* **1910–11**

Henry lived on Achill Island, Co. Mayo, for several years, sensitively recording its inhabitants and terrain. Here, five fishermen drag their boat towards the incoming tide. This work was created shortly after his arrival on Achill, when he focused on the harsh realities of the islanders' existence. The currach was ideally suited to their needs; being made of wickerwork and hide, it was lightweight, capable of negotiating both shallow waters and rough seas, and did not require a harbour.

M	T	W	T	F	S	S
25	26	27	28	29	30	1
2	3	4	5	6	7	8
9	10	11	12	13	14	15
16	17	18	19	20	21	22
23	24	25	26	27	28	29
30	31	1	2	3	4	5

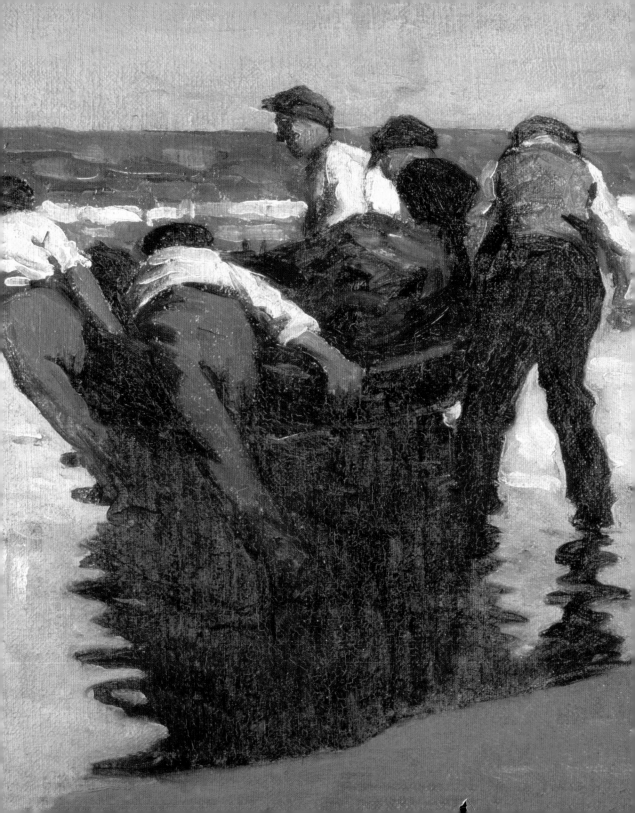

List of Works

Antoniazzo Romano (Antonio Aquili) (first doc.1461-died 1508/12), *The Virgin invoking God to heal the Hand of Pope Leo I,* c.1475, Egg tempera and gold leaf on wood panel NGI.827

Frederic William Burton (1816-1900), *Cassandra Fedele, Poet and Musician,* 1869, Black chalk on paper NGI.2385

Charles Lamb (1893-1964), *Loch an Mhuilinn,* 1930s, Oil on board
© Laillí Lamb de Buitléar NGI.4670

Clare Marsh (1875-1923), *Head of a Young Boy perhaps in Uniform,* early 20th century, Watercolour and gouache with traces of graphite on paper NGI.19596

Studio of Willem van de Velde the Younger (1633-1707), *Calm: the English Ship Britannia at Anchor,* 1700-10, Oil on canvas NGI.276

Augustus Edwin John (1878-1961), *James Joyce in October 1930,* 1930, Graphite on paper Courtesy of the Estate of the Artist / Bridgeman Art Library. NGI.6876

Thomas Sword Good (1789-1872), *An Old Scots Woman,* 19th century, Oil on panel. NGI.472

Kees van Dongen (1877-1968), *Stella in a Flowered Hat,* c.1907, Oil on canvas
© ADAGP, Paris and DACS, London, 2012. NGI.4355

Harry Kernoff (1900-1974), *A Woman Holding a Flower,* 1927, Watercolour, ink and graphite on card. NGI.3164

Gerard Dillon (1916-1971), *The Artist's Studio, Abbey Road,* c.1940s, Oil on board
© Artist's Estate. NGI.4733

William Orpen (1878-1931), *Sunlight,* c.1925, Oil on panel. NGI.956

Mildred Anne Butler (1858-1941), *Shades of Evening,* 1904, Watercolour on paper. NGI.7953

Conrad Faber von Creuznach (c.1500-c.1553), Portrait of *Katherina Knoblauch,* 1532, Oil on limewood panel NGI.21

Edgar Degas (1834-1917), *Two Harlequins,* c.1885, Pastel on paper. NGI.2741

Berthe Morisot (1841-1895), *Le Corsage Noir,* 1878, Oil on canvas. NGI.984

Alessandro Oliverio (active during the first half of the 16th century), *Portrait of a Young Man,* c.1510-20, Oil on wood panel. NGI.239

Sebastiano del Piombo (c.1485-1547), *Portrait of Cardinal Antonio Ciocchi del Monte (1461-1533),* c.1512-15, Oil on canvas (originally on wood). NGI.783

Roger Fry (1866-1934), *Red Earth,* 1908, Oil on canvas NGI.1124

Alfred Sisley (1839-1899), *The Banks of the Canal du Loing at Saint-Mammès,* Oil on canvas 1888. NGI 966

Govaert Flinck (1615-1660), *Head of an Old Man,* c.1642, Oil on wood panel NGI.254

Sassoferrato (Giovanni Battista Salvi), (1609-1685), *Madonna and Child Seated in Clouds,* 1650s, Oil on canvas. NGI.93

Giovanni Paolo Panini (1691-1767), *Preparations to Celebrate the Birth of the Dauphin of France in the Piazza Navona,* 1731, Oil on canvas. NGI.95

Peter Paul Rubens (1577-1640), *Saint Peter Finding the Tribute Money,* 1617-18, Oil on canvas NGI.38

Stanley Royle (1888-1961), *The Goose Girl,* c.1921. Oil on canvas
Courtesy of the Estate of the Artist / Bridgeman Art Library. NGI.4009

Pierre Bonnard (1867-1947), *Le Déjeuner,* 1923, Oil on canvas © ADAGP, Paris and DACS, London 2012 NGI.2006.23

Mary Swanzy (1882-1978), *Pattern of Rooftops, Czechoslovakia,* 1919-20, Oil on canvas
© Artist's Estate. NGI.4663

Bartholomeus van der Helst (c.1593-1649), *Portrait of Maritge Jansdr. Pesser,* 1647, Oil on wood panel NGI.65

Jean Baptiste Edouard Detaille (1848-1912), *A Cavalry Officer,* 1887, Oil on canvas. NGI.1292

Francesco Guardi (1712-1793), *The Doge Wedding the Adriatic,* c.1780, Oil on canvas. NGI.92

Roderic O'Conor (1860-1940), *The Farm at Lezaven, Finistère,* 1894, Oil on canvas. NGI.1642

Hermann Max Pechstein (1881-1955), *Houses with Gardens,* 1920, Oil on canvas. © Pechstein Hamburg, Toekendorf / DACS, 2012. NGI.2006.11

Patrick Tuohy (1894-1930), *Supper Time,* c.1912, Watercolour, traces of graphite underdrawing and gum glazes on paper NGI.3306

Mary Delany (1700-1788), *Swift and Swans Island in the Garden of Delville,* Dublin, 1745, Ink, graphite and wash on paper NGI.2722.24

Walter Frederick Osborne (1859-1903), *Portrait of J.B.S. MacIlwaine, Artist and Inventor,* 1890, Oil on canvas. NGI.882

Jules Breton (1827-1906), *The Gleaners,* 1854, Oil on canvas. NGI.4213

Erik Lange (1876-1946), Signs of Spring, 1920, Colour woodcut, Swedish School, NGI.20919.

Harry Clarke (1889-1931), *The Song of the Mad Prince,* 1917, Stained glass panel NGI.12074

Francisco José de Goya y Lucientes (1746-1828), *Doña Antonia Zárate,* c.1805-06, Oil on canvas NGI.4539

Jan Steen (1626-1679), *The Marriage Feast at Cana,* 1665-1670, Oil on canvas Sir Alfred and Lady Beit Gift, 1987 (Beit Collection) NGI.4534

Willem Drost (active 1652-1680), *Bust of a Man Wearing a large-brimmed Hat,* c.1654, Oil on canvas NGI.107

Ernest Meissonier (1815-1891), *A Group of Cavalry in the Snow: Moreau and Dessoles before Hohenlinden,* 1875, Oil on wood panel. NGI.4263

Jack Hanlon (1913-1968), *Fiery Leaves,* 1935-38, Watercolour on paper, Irish School, NGI.6888.

Vincent Van Gogh (1853-1890), *Rooftops in Paris,* 1886, Oil on canvas NGI.2007.2

William Orpen (1878-1931), *Looking at the Sea,* c.1910, Oil on wood panel. NGI.956

Camille Pissaro (1830-1903), *Chrysanthemums in a Chinese Vase,* 1873, Oil on canvas. NGI.4459

Helen Mabel Trevor (1831-1900), *The Fisherman's Mother,* c.1893, Oil on canvas. NGI.500

Frederic William Burton (1816-1900), *Hellelil and Hildebrand, or the Meeting on the Turret Stairs,* 1864, Watercolour and gouache on paper. NGI.2358

Robert Ponsonby Staples (1853-1943), *On the Beach, Broadstairs, Kent,* 1899, Oil on canvas. NGI 4712.

Jacques Yverni (d.1435-1438), *The Annunciation,* c.1435, Tempera on wood panel. NGI.1780

Pablo Picasso (1881-1973), *Still Life with a Mandolin,* 1924, Oil on canvas
© Succession Picasso / DACS, London 2012 NGI.4522

Frans Hals, Circle of (c.1581-1666), *The Lute Player,* c.1630 Oil on canvas Sir Alfred and Lady Beit Gift, 1987 (Beit Collection) NGI.4532

Bartolomé Estebán Murillo (1617-1682), *The Holy Family,* c.1650s, Oil on canvas. NGI.1719

Paul Henry (1876-1958), *Launching the Currach,* 1910-11, Oil on canvas
© Estate of Paul Henry, IVARO, Dublin, 2012 NGI.1869

Additional credits

FRONT COVER Francisco José de Goya y Lucientes (1746-1828), *Doña Antonia Zárate,* c.1805-06, Oil on canvas. NGI.4539

BACK COVER Jules Breton (1827-1906), *The Gleaners,* 1854, Oil on canvas NGI.4213

ENDPAPERS Harry Kernoff (1900-1974), *St Michael's Hill, Winetavern Street, Dublin,* 1934, Signed photomechanical print
© Artist's Estate NGI.11932.24

Page 1: Bartholomeus van der Helst (c.1593-1649), *Portrait of Maritge Jansdr. Pesser,* 1647, Oil on wood panel. NGI.65

Page 2: Patrick Joseph Tuohy, 1894-1930 *Portrait of Biddy Campbell, Daughter of the 2nd Lord Glenavy,* 20th century, Oil on canvas. NGI 4027

Page 3: Moyra Barry (1886-1960), *Self-Portrait in the Artist's Studio,* 1920, Oil on canvas © Artist's Estate. NGI 4366

All photographs are © National Gallery of Ireland unless stated otherwise.